A–Z

OF

BUNGAY

PLACES - PEOPLE - HISTORY

Christopher Reeve

AMBERLEY

First published 2020

Amberley Publishing
The Hill, Stroud, Gloucestershire, GL5 4EP
www.amberley-books.com

Copyright © Christopher Reeve, 2020

The right of Christopher Reeve to be identified
as the Author of this work has been asserted in
accordance with the Copyrights, Designs and
Patents Act 1988.

ISBN 978 1 4456 9824 3 (print)
ISBN 978 1 4456 9825 0 (ebook)

British Library Cataloguing in Publication Data
A catalogue record for this book is available
from the British Library.

Typesetting by Aura Technology and Software
Services, India. Printed in Great Britain.

Contents

Acknowledgements

My chief debt of gratitude is once again to Martin Evans, who has dealt with the arduous and time-consuming task of creating photographic images and preparing them for publication. Martin himself was a Furriner (the local term for any newcomer to the town – see Introduction), moving to Bungay in 1977, and has integrated so successfully that he has been elected town reeve, town mayor, and is involved with a large number of organisations, including the Bungay Society, the Bungay Museum, the Community Centre Committee, and the Friends of St Mary's Church – all very busy and responsible occupations. Yet, even so, he has remained generous with his time in assisting with all my Amberley publications.

May his name be brightly illuminated in that heavenly volume on high, in which we are told the good deeds of all the saints are recorded.

Introduction

This is the sixth book I've published with Amberley, and it's given me a great deal of pleasure, partly due to its format of twenty-six short essays on varied subjects.

For many years I've contributed articles titled *Bungay Bitesize*, to a regional magazine, originally named *Bungay & Beyond*, but now taken over by another publisher and called *Village People.* My contributions are usually around 400 words in length and devoted to a range of topics reflecting Bungay local life and history, designed to be enjoyed by readers during a morning break with coffee and a choccy biccy, or in bed at night before you snuggle under the duvet on a chilly night.

So I've had plenty of practice writing the bite-sized entries for this A–Z of Bungay, and it was fun selecting the topics, which changed quite a bit until I found just the right themes.

I've aimed to make the topics unusual, rather than just writing about well-known features and characters. So, for example, Bungay floods partly come under S, for *Swan Lake,* my favourite ballet; U features Urchins, which predominated in town life for centuries but fortunately no longer exist due to the introduction of the Welfare State in 1945; and I realised that with E for Eccentrics, I couldn't include ones that we see on the streets every day (although I would dearly love to), for fear of giving offence, or even being taken to court for libel.

One of my greatest pleasures is living in the town of Bungay, and another is writing about it. When I was growing up in the 1950s, the place was rather introverted. This was partly due to the economic effects of the war, which resulted in most of the workforce remaining in local employment because they couldn't afford to move about regularly as people do today, and lacked the transport. Also school leavers tended to take safe employment options, deciding to apply to Clay's, the town's major printing firm, or other local businesses. It was regularly said that if new people moved into our town, it would be twenty years or more before they ceased being treated as 'Furriners'.

However, as the whole country began to prosper during the latter years of the twentieth century, attitudes changed. Most school leavers now will move long distances away to university, or to find better employment opportunities, and Bungay has gradually become a very popular place for people to move and retire to, or even purchase a holiday home.

And that's due to its picturesque and peaceful rural location, appealing to artists and writers and all those who love outdoor pursuits, walking, cycling, canoeing,

bird watching, and even wild water bathing in the Waveney. So instead of remaining stand-offish and suspicious, Bungay now has a very warm sense of community, as more newcomers settle here and find a wide variety of events and activities to get involved with.

The Bungay Fisher Theatre, the annual July Festival, and the Bungay Black Dog Marathon are just three significant factors in this transformation. Long may it continue to prevail!

*

Angels

What better way to commence a book than with angels, which had a great significance for our ancestors, although they seem to have little relevance for us today, even for those who regularly participate in Christian church worship.

Angels are defined as spirits, superior to humans in power and intelligence, and who are the attendants and messengers of God, as referred to throughout the Christian Bible. They are depicted in art throughout the centuries as human in appearance, but with large wings, and usually with golden haloes around their heads, signifying their holy nature. From early times they were classified as male, but by the Victorian period female types, or an androgynous appearance, are depicted in artists' impressions.

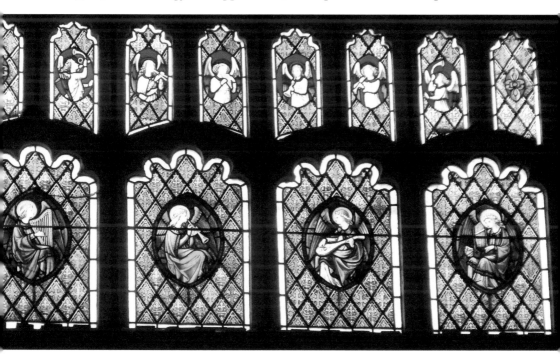

Stained-glass window depicting angels by J. Powell & Sons, St Mary's Church, *c.* 1870.

Angels have been associated with children, as their attractive faces and kindly character was a way of making religion easier to understand, compared with the rather stern figures of saints and disciples, which proliferate in Christian art. They were believed in as guardians, and appear in the prayers that children were taught to learn and recite at bedtime, as well as in hymns and poems. For example:

> There are four angels round my bed,
> Two at the foot, two at the head,
> Matthew, Mark, Luke, and John,
> Bless the bed that I lie on.

They provided great comfort for children, when frightened by the dark and what it might hide, and a way of helping to deal with everyday fears and anxieties as well, particularly because children often find it difficult to express their concerns to parents, and other grown-ups.

The Bungay churches would have had various images of angels, in paintings, carvings, sculptures, textiles, and stained glass, in the mediaeval period, but these, along with all other images deemed superstitious, were banned and removed by the church authorities during the Protestant Reformation in the Tudor period.

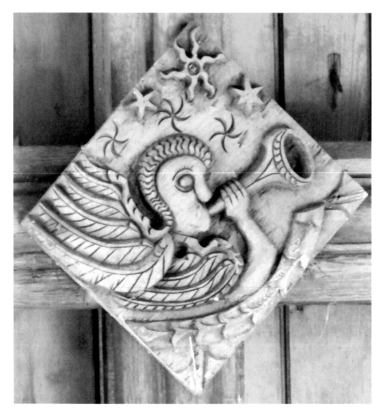

Wooden roof boss depicting a trumpeting angel, St Mary's Church, late seventeenth century.

In the Victorian era, many churches throughout the country reintroduced depictions of the Holy Family, disciples, saints and angels into the decoration of church interiors, but the Bungay churches were not greatly changed.

St. Mary's Church has a seventeenth century carved angel blowing a trumpet on a wooden boss in the church roof, and there are groups of angels playing musical instruments in the high east window above the altar. Rather too high to view clearly, which is unfortunate as they are rather lovely. It was made by glass artists J. Powell & Sons around 1870.

It is sad that angels, along with many other spiritual and supernatural presences held in veneration and respect by our ancestors, have been largely ousted by today's scientific and materialistic modes of thought.

The Bungay motto, attached to its coat of arms, is '*Moribus antiquis pareamus*' – 'Let us hold fast to the old virtues' – which in past times would be associated, among other things, with such radiant winged beings as the angelic host.

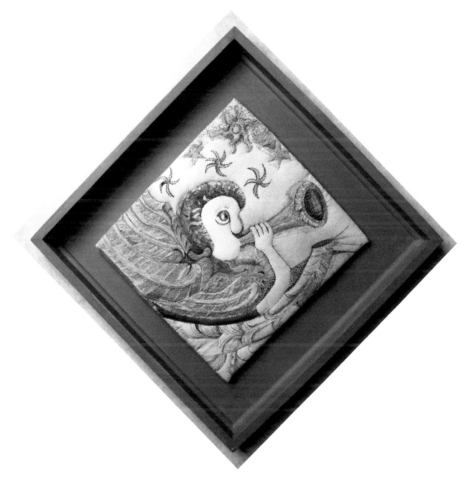

An embroidery designed by Mary Walker depicting the angel roof boss, St Mary's Church.

Bardwell, Thomas

A blank memorial slab and a weathered cherub on the west wall of St Mary's Church are all that survives to commemorate the most famous artist associated with our town.

Thomas Bardwell's origins are obscure, but he was born in or near Bungay, and was buried in the churchyard in 1767, aged sixty-three.

He was first employed as a painter of decorative panels for his father's business in Bungay, but gradually developed sufficient skills to embark on a career as a portrait painter. It was a lucrative profession, as an increasing number of middle-class families were keen to ape the gentry and have their images depicted for posterity.

One of his earliest portraits depicts the Brewster family of Beccles, and his portrait of Maurice Suckling wearing the uniform of a naval captain is considered to be one of his finest local commissions. He also made an interesting drawing showing the Bath House at Ditchingham viewed from Outney Common, engraved as the frontispiece

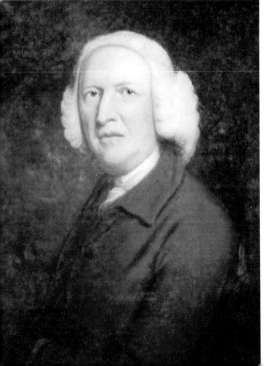

Self-portrait by Thomas Bardwell, oil on canvas, *c.* 1760.

for *An Essay on Hot and Cold Bathing* by John King, published in 1737, soon after king established his fashionable spa near the Bath Hills.

Bardwell later acquired a studio in Norwich, and did so well in his career that he won commissions to paint various mayors of the city, which can still be seen in St Andrew's Hall. He was skilled at capturing a sitter's personality, and depicting the fine fabrics, fur, velvet, silk and lace of their costumes.

Most of his later career was spent in Norwich, and when he died he was described in the local press as 'an eminent portrait painter of this city'.

He had continued his connections with Bungay, choosing to be buried here, and had his only daughter, Elizabeth, educated at a boarding school in the town.

It is planned to have a drawing of his memorial made, with the original inscription, and put on display in the church, so our eminent Bungayan is not neglected in his home town.

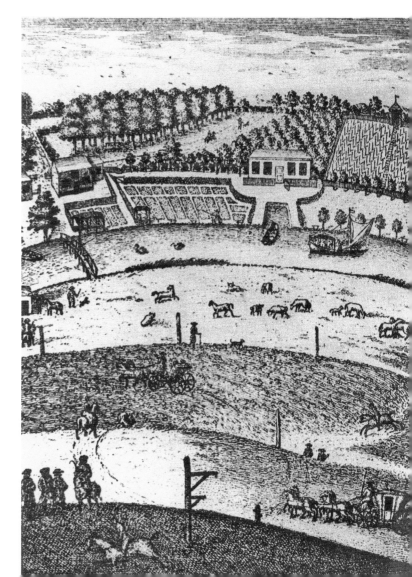

The Bath House, viewed from Outney Common, engraving from a drawing by Thomas Bardwell, 1737.

Castle Hospitality – 1269–70 Bigod Court Roll

Some account rolls relating to the manor of Bungay survive, when it was in the possession of the powerful Bigod family, who built Bungay Castle. They cover the years 1269–1306, and are in the archives of the Public Record Office in London.

The roll from Michaelmas Day, 29 September 1269, to Michaelmas Eve 1270, contains interesting details concerning the hospitality provided by the Bigods to their guests. It seems likely that these were accommodated in the castle, which although getting dilapidated was still partly occupied by the family, although their main seat had become Framlingham Castle, which was substantially rebuilt in the Late twelfth century.

The Bigods had a forested area at Stow Park, adjacent to the Flixton road leading from Bungay. It was used for hunting, and it's believed that their hunting lodge was situated on the crest of the hill slopes, perhaps near the site of the existing ancient Stow Park House. The remains of a stone-built Norman chapel, quite close to the house, were discovered in 1857.

The document of 1270 describes Stow Park as being grazed by wild animals, which would include hogs, fed on acorns from the oak forests, and sheep, wild boars, hares and rabbits, as well as deer. It contained 112 acres and an alder ground. Nearby on lower marshy land is Stow Fen, comprising 20 acres, with other large acreages of pasture and woodlands adjoining.

The roll mentions expenses resulting from three visitors, John Stunbare, Richard Cook and John Bernar, 'and others with them for eight days, in dog food, when they hunted in Stowe Park and Earsham Park'. The expenses also included fodder for the men's horses – one quarter of oats. Other guests included wealthy aristocrats, such as the Earl of Gloucester, who stayed on the 'Wednesday after Saint Laurence Day' (10 August). The expenses resulting from his visit totalled 17s 6d, a large amount so he was obviously treated with VIP hospitality.

Hunting was the most popular pastime for the wealthy in the medieval period. It was termed 'the sport of kings' and enjoyed by women as well as men. Edward, Duke of York wrote a treatise on hunting in around 1406, in which he affirmed that

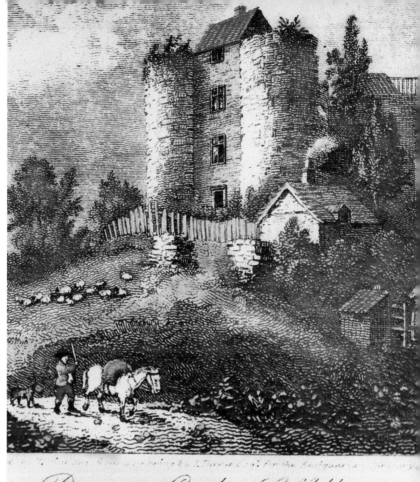

Bungay Castle, Suffolk.

Right: Engraving of
Bungay Castle, 1816,
by Thomas Higham.

Below: Medieval
scene of hunting
with hounds.

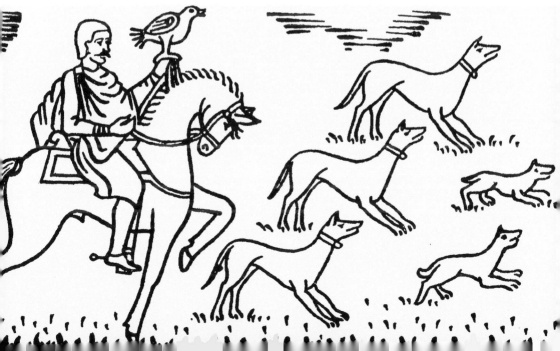

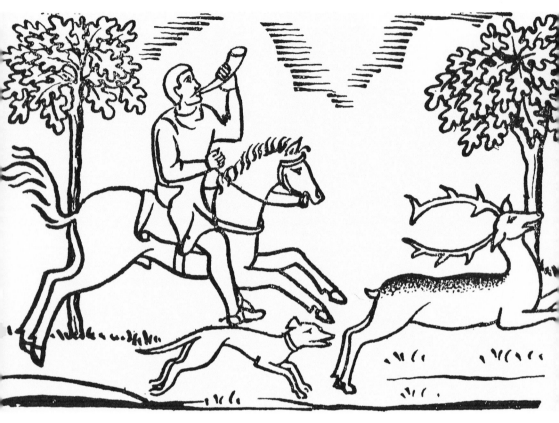

A huntsman in pursuit of a stag.

hunters lead a vigorous life, that keeps them fit, they sleep well, and are careful of what they eat. They avoid sin, have joy in their hearts, and are not beset by evil humours that result in ill-health, so live longer than other men, before going straight to Paradise when they die. He clearly viewed this as the eternal happy hunting grounds waiting in Heaven for men and dogs. He also advocated the sport as a preparation for military training for sons of the nobility, because it fostered individual prowess and chivalric single combat, involving dangers and lots of blood. The medieval age, like preceding Greek, Roman and Saxon civilisations, glorified warfare, and not until more recent times, and partly as a result of the horrors of the two world wars, has a more pacifist attitude prevailed.

D

Dinky Payne

As we old Bungayans tootle around the town centre, calling in at Boot's the chemist for pills, collecting a novel from the library, buying a punnet of strawberries from Simon the Greengrocer, and pausing often to chat with friends and neighbours, we sometimes reflect on those familiar faces that have vanished from the scene. People who have moved away, become house-bound, or maybe died without our knowing, and we realise their presence is now lost from the streets forever.

We heave a sigh of regret, then they are all but forgotten. But some remain fixed in our minds, colourful individuals who are fondly recalled in street conversations and in our own private musings as we go about our daily routine.

One such character is Dinky Payne. She was a woman of striking appearance, squat build, a bush of thick hair, sun-burned skin, sharp dark eyes, and a brisk and

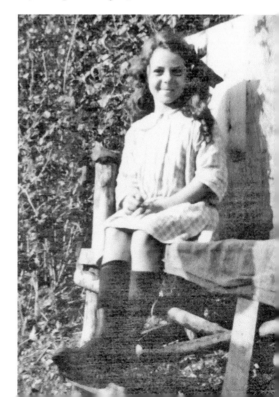

Dinky Payne, aged ten, in her grandparents' garden in Castle Lane.

assertive manner. She could seem alarming with her forthright opinions – 'That ole Castle, that's just a heap of ruins, they should knock it down, Dear, and build a car-park!'

She wouldn't stand any nonsense from anybody, and if she had a grievance would soon make her feelings known. Even towards the end of her life, at the age of ninety-one, threatened by a man who had broken into her terraced house in Lower Olland Street, she accosted him so fiercely that he ran off in terror.

But she had a warm and tender heart, quickly dissolving into tears if something touched her deeply, problems affecting friends or family, or reading of tragedies in the local press. For a local CD recording 'Bungay – Our Town in Sound', she sobbed as she remembered her schooldays and the little children from poor families who had to trudge through the snow to school and got painful chilblains, as they had no weather-proof boots to protect their feet in the bitter winter weather.

There was much more to her than just a vivid personality. She achieved fame as 'Dinky – the Local Fundraiser'. This began in 1974, when, in her late sixties, she was watching a television programme about kidney machines in hospitals. She was shocked to discover that, due to insufficient funding, 'the doctors said they had to pick who was to live and who was to die, and I thought – What a dreadful thing in this day and age, Dinky – Well, it's no good worrying about it unless you do something about it'.

So she decided to commence her own fundraising, organising jumble stalls at the old Trinity Parish Rooms, where the library now stands in Wharton Street, and eventually raising the magnificent sum of £4,500 for a kidney machine for the West Suffolk Hospital.

Fired by her success, Dinky decided a more regular slot was needed and commenced a weekly stall in the yard of the Angel pub near her home. She and her husband Sid manned it on Market Day, Thursdays, and, later on, on Saturdays, as well when there were plenty of shoppers about.

Her stalls became a popular fixture before charity shops prevailed, as they do today, and attracted customers from miles around. She sold all sorts of goods:

Dinky Payne at her charity stall in the Angel Yard.

second-hand clothes, crockery, bric-a-bac, furniture, children's toys, and, on one occasion, was offered a pony and trap, which fetched £500. She also organised a team of knitters who provided a variety of useful and fancy items in bright colours. Her feisty character continued; customers were sent away with a flea in their ears if they haggled over prices, and on one occasion she chased a man down the street when she caught him pilfering her goods.

Over the years the stall raised hundreds of thousands of pounds for various charities. These included All Hallows Hospital, which benefitted from new medical equipment, the East Anglian Air Ambulance and Guide Dogs for the Blind. It's estimated that she helped fund more than a hundred good causes, and her success was frequently heralded in the *Eastern Daily Press* and *Beccles & Bungay Journal,* with headlines such as *'DINKY DOES IT AGAIN'* and *'MOTHER CHRISTMAS ALL THE YEAR ROUND'.*

Terry Reeve, former editor of the *Journal,* wrote in an interview with her in 1991: 'There she stands, behind her stall, enjoying the banter, sorting out items with her helpers throughout the year. Sometimes in the late summer, when the sun has turned her face and arms deep brown, she reminds me of a cheerful bronze chrysanthemum, as she goes about her work in the Angel Yard, or organises her presentations in the nearby pub two or three times a year'.

In 1983, she was rewarded with the British Empire Medal, and, later on, interviewed on TV by Harry Secombe for his Sunday programme series *Highway.* Bungay Town Council honoured her by creating 'Dinky's Garden' adjacent to the Angel pub. It was officially opened by Town Council Chairman Arthur Fisher in 1996. It consists of a paved courtyard and benches, surrounded by flowering shrubs and tubs of summer blooms, and there is a commemorative brass plaque by the entrance. Throughout the years it has been lovingly tended by volunteers and the Bungay in Bloom team, and remains a colourful tribute to Dinky, who died, aged ninety-two, in 2008.

She remained cheerful and energetic into old age, and even when in considerable pain declared 'I just hope God will spare me until I've used up all my knitting wool'. Courageous and keen to continue her good works until her last breath.

Dinky Payne at the official opening of the garden commemorating her charitable fundraising, 1996.

Eccentrics

Small towns always have their local eccentrics, individuals who are set apart by their weird appearance or peculiar behaviour, and might be treated either with cheeky humour, disdain, or even hostility by the more 'normal' local residents. They can be of any social class – wealthy, middling, or poor – and whereas the poor eccentrics may be treated with ridicule by those who should know better, the upper-class eccentrics are treated with respect to their faces and then gossiped and joked about as soon as their backs are turned. We all tend to be guilty of it, in one way or another, little knowing that we too may be the butt of others wit and insensitive comments.

I can think of at least six eccentrics regularly seen in Bungay today. But no, I can't reveal who. One of them might be you.

Eccentric characters in the past were often poverty stricken, and so noticeable for their weird and shabby clothing, bad teeth, or physical impediments because they couldn't afford the medical care that was needed before the National Health Service was introduced in 1948.

I can remember being frightened by peculiar characters as a child in the 1950s. A rough old man with a battered cap and unshaven chin used to push a little wooden cart around the town, collecting odd bits of wood or junk and taking them away to sell. On one occasion when I was around seven he shouted at me, ''Ere Boy – 'Elp me push this cart'. Of course, I didn't dare refuse, so, shaking all over in fright, I helped him push the cart down the street feeling very self-conscious to be seen with such an eccentric character. Then I made a sudden dash for it, rushing off round a corner and home as fast as my legs would carry me. Fortunately he didn't ever accost me again.

Then there was the old woman who suddenly loomed out of the evening dusk when I was walking in Castle Lane. She had a flat, white face with a dazed expression, and was shaking all over from head to foot.

I thought she was a strange ghostly apparition, but it turned out that she lived in Castle Lane and was sadly suffering from 'Saint Vitus Dance', as it was termed.

One notorious eccentric, in the Victorian period, was 'Blood' Skippen, a real countryman involved in poaching and other illegal pursuits. He lived in an old hovel on the piece of land called 'Lord's Drift', off Outney Road, and he kept a large number

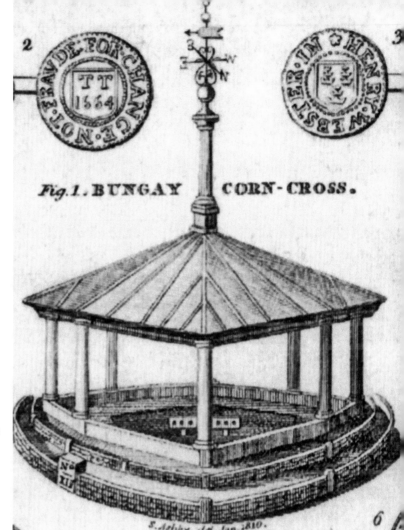

Fig. 1. BUNGAY CORN-CROSS.

S. Ashby, del. Jan. 1810.

Right: Engraving of the Bungay Corn Cross, 1810, depicting the stocks beneath it, from the *Gentlemen's Magazine*.

Below: Bungay Market Place, depicting the Corn Cross and Butter Cross, early nineteenth century.

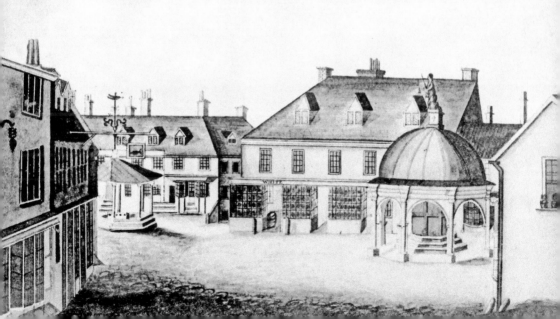

Above: Miscreant being punished in the stocks.

Below: Part of the area known as the Lord's Drift, Outney Road, late Victorian era.

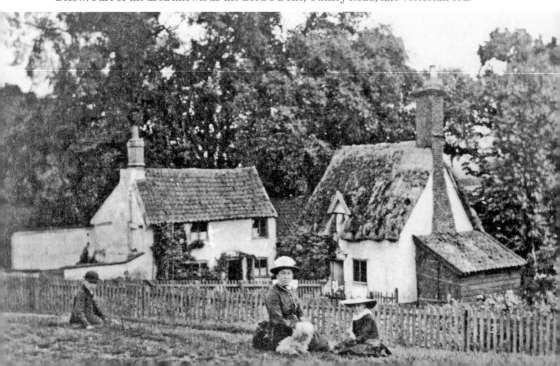

of dogs there, which he trained for hunting, and rabbiting. Harry Botwright, an old inhabitant of Bungay, recalled in 1907 that he had known 'Blood', and one reason he had got his name may have been due to 'the filthy state of his clothes from carrying horse flesh on his back for the dogs he had in training'. But Botwright believed the real reason he got his name was due to a vicious fight in the Market Place, when he had bitten off his opponent's ear.

'Blood' was the last person to be punished in the stocks in the Market Place before they were removed in 1810, when the Corn Cross beneath which they were situated was demolished. He was imprisoned in them for two hours on that occasion. Depending on the mood of the locals, he may have been jeered and pelted with obnoxious missiles, but it's more likely that many of them admired him as a colourful local character, who didn't deserve such rough treatment.

He had a brother named Goat Skippen. I wondered whether he had acquired this name (or nickname) because he kept herds of goats on the Lord's Drift, near his brother's dog breeding premises. However, the parish registers record his name as Goat, so it seems it wasn't just a nickname.

Like 'Blood' he was often in trouble and punished in the stocks.

St Edmund's Almshouses, built on the Drift in 1895.

The Cherry Tree pub, Outney Road, *c.* 1900.

At the time of his death, 9 March 1855, 'Blood' was living in the Cherry Tree Inn. As this was close to the 'Lord's Drift', adjacent to Webster Street, it seems likely that when he grew feeble in old age, he was taken in by the landlord of the Cherry Tree, who took care of him for the remainder of his days.

An eccentric of a very different kind was Mr Webb, a wealthy philanthropist who visited Bungay on 31 October 1813, and lodged at the King's Head Hotel. He remained for five days and during that time handed out money to poor residents, and in particular for the benefit of young men and boys, offering them sums of between £1 and £5, which had a large spending value in the period. He also arranged apprenticeships for learning trades, providing prospective employers with large sums – £15, £20, and £25 each, and in one case the handsome sum of £36. It was estimated that the total amount he left with his bankers for these charitable purposes was around £1,500. Later on, in the same year, he visited Yarmouth and Norwich offering similar donations.

F

Flooding and Freezing

The low-lying water meadows around Bungay are prone to flooding in the winter months and at other times as well. This was more frequent in past centuries, and the name Bungay is thought to derive from various origins, suggesting that in early periods it could be completely surrounded by water: for example 'le bon Eye' meaning the 'good island', or that suggested by the eminent Suffolk historian, Norman Scarfe:'the island of the Reed Dwellers'.

The likely origin of the name is the Saxon '*Bun-incga-haye*', meaning the enclosure of Bonna's tribe, without any watery association.

In severely cold winters in the past, flood water was transformed into big areas of ice on the meadows around the town, with the slow-flowing areas of the river getting frozen as well. So ideal for skating, which became a regular and popular winter activity.

In the eighteenth century the Cock Inn stood by the bridge over the Waveney, separating Bungay from Earsham – now a private residence, Scott House.

Flooding on Ditchingham Dam, 1912.

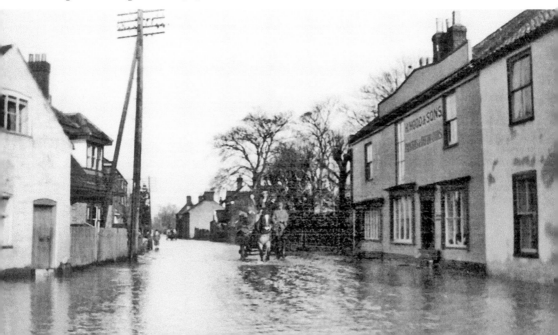

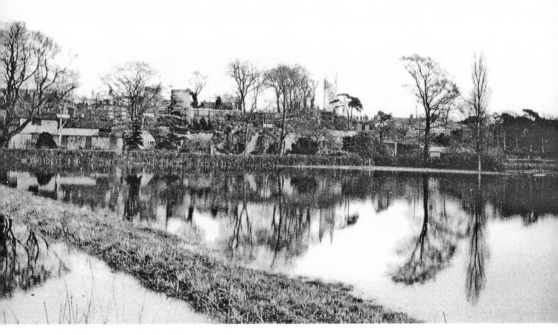

Floodwaters on the Earsham marshes, 1912.

The building was smaller then, later being enlarged and turned into a gentleman's residence by Isaac Reeve, who was the town reeve in 1762–63. He later sold it to the wealthy businessman John Scott, 'tanner, glover, and fellmonger', who developed tannery yards all along the stretch of river from Castle Lane and part of Outney Road.

The meadow alongside the inn regularly flooded and froze. So we can imagine that the landlord of the Cock Inn would take advantage of this as an attraction, and provide hot food, mulled wine and spiced ale, and maybe bed and breakfast accommodation, for all those taking advantage of the ice, as well as a blazing log fire in the hearth for when the skaters trailed in with nipped fingers, purple noses and chattering teeth.

Those who could afford it would have skates made by one of the town blacksmiths, with smoothly polished iron blades to glide gracefully over the frozen wastes. Poorer folk, including young lads, either begged, or paid a few pence, to obtain the shin bones of cattle and horses from the slaughterhouses in Cross Street. They then carved them into the correct shape, and bored holes, threaded through with cord, to attach the skates to their ankles. Not quite so efficient, but nevertheless the lads could often demonstrate skills that those better shod failed to imitate! Older folk and the less agile sometimes used poles to steady themselves and help propel them along.

Skating could, of course, be dangerous, if the ice was thin or started to melt. In Ipswich an excavation of the riverbed in 1899 revealed the skeleton of a woman buried in the mud with bone skates still strapped to her feet. Similar tragedies must have occasionally occurred in Bungay in the deeper parts of the Waveney.

But no dire warnings could deter the young from enjoying the ice while it lasted. Ball games such as ice camping, a rough form of football, and curling, a primitive

Scott House, formerly the Cock Inn, by the Earsham bridge leading out of Bungay.

form of quoits, were exciting variations to just skating. Large crowds of spectators would gather to enjoy the fun and take advantage of the hospitality at the Cock Inn – and you can bet that the landlord prayed for a long cold winter to take full advantage of his popular attraction.

Flooding was fairly regular in past centuries, but has been declining during the past hundred years or so. There was severe flooding in 1912, when the railway lines between Bungay and Harleston were badly damaged. In 1951, flooding and strong winds between January and April caused river levels to rise rapidly around the Earsham and Ditchingham Dams on the outskirts of Bungay. The *Beccles & Bungay Journal* reported that there was hardly a clear road out of town, and makeshift punts were constructed to carry food to stranded poultry and animals on farms.

Bungay was not directly affected by the East Coast Flood Disaster of 1953, but local people rallied to support victims under the leadership of Bungay businesswoman Hilda Nursey. She was a chair of the Womens' Royal Voluntary Service, and an appeal in the town raised £1,148. Mrs Nursey and her helpers set up an emergency laundry service in Yarmouth and Gorleston, washing and ironing flood-soiled curtains, bedding and clothes. An emergency centre was established in Upper Olland Street where clothing could be delivered to victims, and the *Journal* reported the plight of

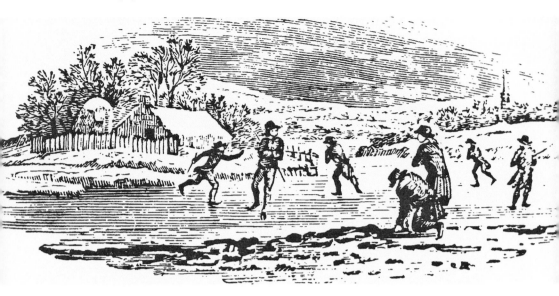

Victorian skating scene

'a small child shivering with fear, cold and exhaustion, huddled in a boat in nothing but a thin nightdress'. Hilda Nursey was later awarded the British Empire Medal for her outstanding services with the WRVS.

In September 1968, severe flooding hit Bungay again, and the main roads were deep in water. It was three days before Ditchingham Dam became accessible, with army troops brought in to supervise the movement of vehicles, while on Earsham Dam a provisional bailey bridge was constructed until the flood levels dropped..

It was Joyce Road residents to the south of the town who suffered the worst, when the Tin River in Hillside Road burst into a roaring torrent, flooding around forty nearby houses to a level of 2 feet or more.

Residents were forced to move upstairs and once again the WRVS helped out by providing hot meals and ensuring the welfare of the frail and elderly.

Bungay has not experienced flooding on this scale since, but with threats of global warming, it seems inevitable that one day the town will become what it was in pre-Saxon times – partly an island again, a Little Venice bobbing on the waters of Waveney.

Guildhall

In St Mary's Street, opposite the church, stands one of Bungay's most ancient buildings, which escaped the Great Fire of 1688 and has been assessed by recent architectural historians to date back maybe to the late fifteenth century.

It's best viewed standing some way back in the churchyard when you can gain the perspective of the whole length of the building, which now comprises three

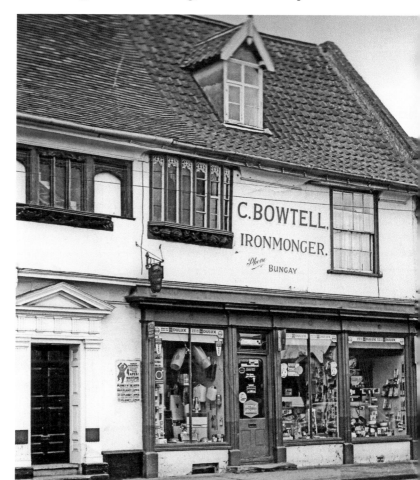

Bowtell's shop, which occupied part of the ancient Guildhall.

businesses: 'Stone Baked Pizzas', the Premier groceries and convenience shop, and Cooper's hardware store, previously Bowtell's. From a very early date it has been one of Bungay's largest secular buildings, and the most prominent one in St Mary's Street.

It's thought that its original use may have been a hostelry providing accommodation for visitors to the Benedictine priory, which was established in the present churchyard from around 1180, founded and funded by the Countess Gundreda, the young widow of Hugh Bigod. Visitors requiring a period of religious retreat for prayer and contemplation could be accommodated in the priory itself, but their relatives and retainers took advantage of the hospitality provided by the hostelry, and could participate in the social life and entertainments of the town.

Guilds, both religious and secular, developed in the medieval period and were formed for the mutual benefit of their members and sharing a common purpose. They could be attached to a church, and in Bungay there was a Guild of Corpus Christi connected with Holy Trinity Church, and a guild vessel for ceremonial occasions is mentioned in the St Mary's parish records. St Mary's had a guild dedicated to the Holy Cross, as well as one for the Blessed Virgin Mary. The church interior had a chapel dedicated to St Ignatius, the patron saint of metalworkers, and it is likely there was a guild connected with him for the benefit of the several blacksmiths employed in the town, as well as other metalworkers including a goldsmith mentioned in the parish records.

There were riots in the town in 1514, connected with the Guild of Corpus Christi. The festival organised by Holy Trinity parishioners was usually held towards the end of May, and was a national holiday celebrated with dancing, games and sports. The highlight was a parade through the town of church dignitaries displaying richly coloured and embroidered banners glittering with gold thread, known as 'pageants'.

On this occasion, on the Friday night following the festival day, it was alleged that the town bailiff, Richard Wharton, employed by the Duke of Norfolk, together with four henchmen, went to the church where the banners were displayed and rudely and roughly tore them down, causing much damage. It seems he may have been motivated by Protestant principles, believing such ceremonies and church objects were redolent of superstition connected with the Catholic Church of Rome, or it may have been only fierce rivalry between his own parish church – St Mary's, not involved with the grandiose procession, and Holy Trinity. The festival feast day may also have been an occasion for drunkenness and lewd behaviour, and, as town bailiff, he needed to maintain law and order.

The repercussions of this conflict were so serious that they had to be dealt with in the Star Chamber proceedings under the authority of Henry VIII. Wharton, of course, had the protection of the Duke of Norfolk, and it's not clear how the issues were resolved. But arguments and enmity between the two parishes continued to rumble on, flaring into conflict again in connection with the pageants in 1537. By this time, Protestantism was well advanced, for in the 1530s King Henry severed all

View of the former Guildhall from St Mary's churchyard.

connections with Papal Rome and established the Church of England under his own supreme authority.

It was very unfortunate that the events of 1514 created problems for the guild, because the organisations generally did a great deal of good for the churches, the town and the community. Church guilds raised funds for running costs, particularly the purchasing of candles and building improvements, and gave special attention to praying for the benefit of the souls in Purgatory of deceased parish members. The Trade Guild members paid a regular subscription and also benefitted from aid when needy, in particular assisting widows and fatherless children, and helping pay funeral expenses. They held business and social meetings and there was an annual feast on the patron saint's day. They raised money for the poor and helped with hospital foundations for the sick.

The parish guilds were the only area of medieval church devotion controlled by the laity. But in 1547, the Chantries Act allowed Henry VIII to dissolve guilds, although the act was fiercely contested and some of the larger urban guilds did manage to survive.

So let's just conclude by picturing how wonderful our ancient Guildhall must have looked in its prime – blazing with the light of many candles shining from the windows across the churchyard, as members celebrated with a festive dinner, wine and ale during the Yuletide season.

Hogs in Churchyards

'Pa! Pa! Come quick! A gret ole Hog's diggin' up Gran-ma !'

In past times churchyards, although venerated as the precincts of God's place of worship, and for the burial and commemoration of the dead, were one of the main areas in a town or village for games and social events. Not all places had a village green so the central open space of the churchyard, where gravestone memorials only started to increase from the late seventeenth century, was the most convenient place for the community to congregate. In the medieval period carol dancing performed in a circle while chanting carols or songs in Latin was very popular but disapproved of by the church

St Mary's Church, ink drawing with watercolour by Jas. Scales, *c.* 1820.

Medieval scene of hogs being fed acorns.

authorities because the songs and other pastimes and activities could often be bawdy – penances were sometimes imposed for this improper behaviour but did little to affect it.

The parish records for St Mary's and Holy Trinity churches refer to these violations, and the attempts to suppress them. One of the major problems was that the open space of the churchyard was also useful for the grazing of cottagers' scanty livestock. In 1783 the parish accounts record paying the town crier on Market Day to warn the residents against letting their hogs feed in the churchyards. Until the late eighteenth century there was not a complete wall or enclosure around St Mary's churchyard (apart from what remained of the original priory wall), and a fence of iron railings was only established in 1791, along St Mary's Street with railings on the other sides added later on. There was also no fence or wall separating St Mary's from Trinity churchyard until a later date.

After these were built, it was announced at the annual town meeting in December 1793:

> it was unanimously agreed that all persons whatsoever not having legal right to do so, are forthwith to have proper notice to shut up and put by all doors and gates leading from their respective houses and yards into the churchyard, and that no person hereafter be permitted to hang or lay any wet or other linen or thing whatsoever in order to be dried or aired there, and no horses, hogs or asses be suffered on any account to be in the churchyard aforesaid.

It wasn't just animals grazing in the churchyards that caused problems – after all, they were to a great extent controlled by their owners, even if they shouldn't have

been there. There were additional issues with stray dogs, and wild creatures that made their homes there, including moles, hedgehogs and birds.

Stray dogs seem to have been numerous throughout the sixteenth to eighteenth centuries. Even in the Victorian period there were at least two 'pounds' for impounding stray animals, which included dogs, as well as cattle, pigs or sheep that might have strayed from their grazing plots. Presumably the dogs were in a separate pound as there would have been more of them and also they might attack other beasts they were retained with. One of the pounds was situated at the junction between Outney Road and Webster Street, so convenient for animals that may have strayed from Outney Common. The other one (but there may have been more) was at the junction of Wingfield Street and Staithe Road, where a grassed area remains central in the road. An early photo of around 1860 shows it as a large brick walled structure with a ladder attached to it, presumably so the stray dogs could be lifted in or out.

The St Mary's Church parish accounts relate to problems with stray dogs. In order to prevent dogs wandering into the church, payment was made in 1544 for 'a hespe of twine for ye nette at the church door – 1d'.

And there were also payments for the verger or some other employee for chasing dogs out of the church. This was obviously a regular occurrence, for in 1569 a man was paid a year's wages for 'whipping dogs out of ye churche', and it remained an expense for fifteen years or more. Holy Trinity had similar expenses, and an altar rail was erected in around 1660 to protect the most sacred area of the chancel, Bishop Wren of Norwich decreeing that 'the rayle be made before the Communion Table reaching crosse from the north wall to the south wall neere one yard in height, so thick with pillars that dogs may not get in'.

There are also regular payments in the Town Trust accounts for 'Crying Mad Dogs' – that is, dogs suffering acutely from rabies – at a payment to the town crier of a shilling per annum.

It seems that the churchyards were left to get rather wild with long grass, saplings and bushes, although payments were recorded for mowing the grass, but maybe only twice yearly. Ethel Mann, in *Old Bungay,* writes that in the eighteenth century, although there are occasional payments for mowing, clearing paths, lopping trees and laying gravel, the churchyards were often overgrown and harboured what were considered as pests. She calculates that between 1771 and 1781, payments were made from the St Mary's accounts to a labourer for trapping: 236 hedgehogs at 4d each; 394 sparrows at 3d a dozen; and an occasional fox for 1s.

One of the serious problems with beasts straying in churchyards was that dogs, foxes and hogs might smell flesh in a newly dug grave and dig into the earth with the chance of exhuming the body. It seems that graves were often quite shallow, with no statutory depth such as we have now, and in periods when poor people couldn't afford to buy a coffin, bodies might just be sewn into a cotton shroud, or wrapped in old blankets. So comparatively easy for roaming beasts to get at, and, of course, absolutely devastating for the family relatives.

I

Illustrations for the Bungay Herbal

The old Fleece Inn in St Mary's Street has been a popular hostelry for around five centuries. Apart from providing accommodation, food and alcohol, it has also been the venue for a wide variety of entertainments, club meetings, parties and other events.

One of the organisations that held regular meetings in the upstairs Club Room was the Bungay Botanical Society. It was formed in around 1828, and, as all the officers listed in its handbook are men, it seems that women were probably excluded, as they often were in stuffy nineteenth-century Britain.

Meetings were held every three weeks on a Monday. Members paid 5s to join, and 8d for every attendance. These were quite large sums of money for the period, so only the prosperous townsmen could afford to join.

The fees were partly used to purchase a library of books relating to the study of plants, and also a collection of dried specimens, referred to as the Herbarium. One of the books purchased is likely to have been *The Family Herbal of English Plants,* by Sir John Hill,

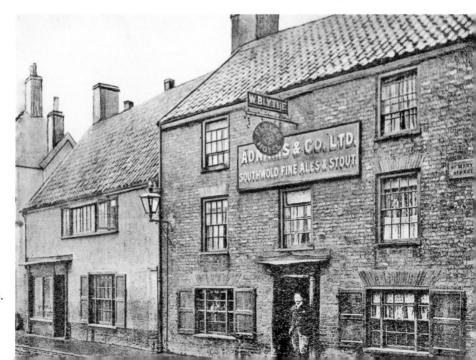

The Fleece Inn, *c.* 1890.

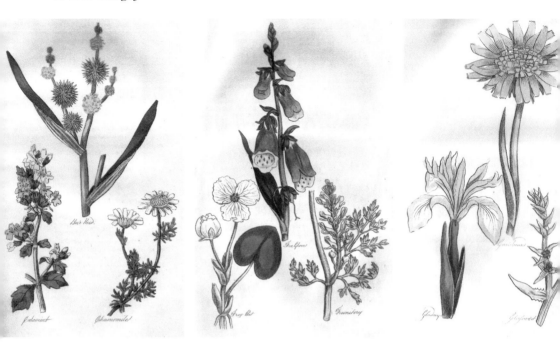

Above left: Hand-coloured illustration depicting camomile and other flowers. From the *Family Herbal of English Plants* by Sir John Hill, 1812, published by C. Brightly & T. Kinnersley, Bungay.

Above middle: A foxglove and other flowers.

Above right: Yellow goats beard, and other flowers.

issued in 1812. It was published in Bungay by C. Brightly & T. Kinnersley, who established the prosperous printing works, later managed by John Childs, and then Clay's.

There is a copy of the book on display in Bungay Museum. It contains fifty-four beautiful engravings of flowers, all hand-coloured. They were painted by local girls, who probably worked from home. They were paid a penny for each print, and one wonders whether they picked bunches of local wild flowers to copy from, or whether they were provided with a written description by the publishers.

At each meeting of the Bungay Botanical Society, members were invited to bring plants for identification, and at the end of the year, the person who exhibited the highest degree of knowledge was elected as the new president. It's amusing to think that the girls who coloured the prints probably became very knowledgeable themselves but were, of course, excluded from the Botanical meetings like all other females.

There was also an annual feast on the Tuesday before Midsummer's Day, when the Club Room was gaily decorated with all sorts of flowers and the public were invited in to admire them. Did the members create these dainty displays themselves? Perhaps for this particular event, their wives and sisters were magnanimously permitted to assist, and even the poorly paid print girls could poke their noses through the door to enjoy the gay floral occasion. But the feasting was strictly reserved for the men.

J

Junior Cup Champions

In 1892, the Chaucer Press football team (which included six employees of Clay's printing works) achieved a triumphant success in winning the Suffolk Junior Cup. The match was at Ipswich, their opponents were Brantham Athletic, and it was 4-1 victory for Bungay.

A report in the *People's Weekly Journal*, 19 March, describes the subsequent celebrations:

> The Chaucer Press footballers met with a hearty reception on their return to Bungay on Saturday evening. The news of their victory in the final match at Ipswich for the Junior Cup tie had preceded them by wire (telegram), and on the arrival of the train they were cheered by a large assemblage of friends, and escorted through the town in a wagonette, drawn by hand, and illuminated with Japanese lanterns.

The Chaucer Press football team, winners of the Suffolk Junior Cup, 1892.

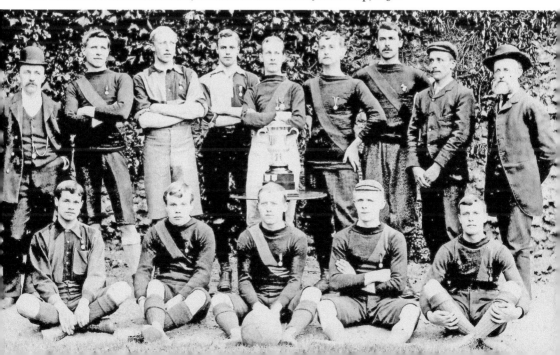

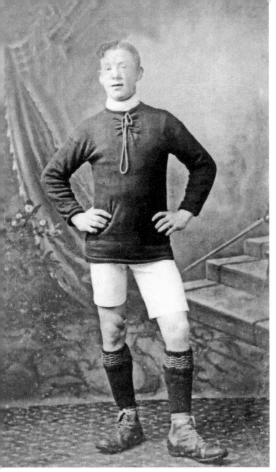

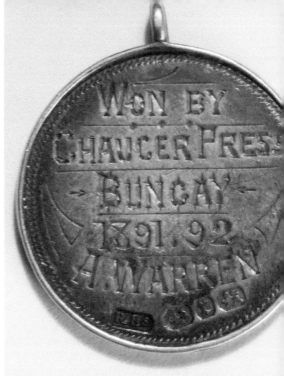

Above: The commemorative Suffolk Junior Cup silver medal awarded to the Chaucer Press football team players in 1892.

Left: George Warren in his football strip, 1860s.

The procession was headed by the Rifle Volunteers Band, which played 'See the Conquering Heroes Come'. After halting at the Market Place, the cup was displayed and the band burst into the song of 'Old Bungay'.

In his history of the town's football clubs, *Wheel'em In, Bungay !* Terry Reeve comments that it was fifty-eight years before a county trophy was awarded to our part of the Waveney Valley again.

The museum has a photo of the winning team on display, which includes Alfred Warren, a keen amateur player in his teens. Alfred's great grandson, Barry Anthony, has donated a photo of George, Alfred's father, another keen footballer, to the museum. Taken in the late 1860s, it depicts him in full football gear and illustrates that football strips have not changed that much in the past 150 years. The noticeable difference is his boots: ankle-length and made of heavy brown leather, much like the ones that we wore at Bungay Grammar School when I was a pupil in the 1950s. The studs were made of leather, and, as they wore down quickly, the old ones had to be removed and new ones nailed into place at the beginning of each season. Sometimes the nails pierced through into the soles of the foot, causing sudden pain during a match. Plastic screw-in studs were an innovation in the early 1960s, and boots today, of course, are much lighter, with studs moulded into the soles. The photo of George is the museum's earliest known depiction of a Bungay footballer.

K

Kathleen Bowerbank

Riding a quaint 1940s bike around the town well into her late seventies, wearing a rusty old mac and a shabby headscarf, nobody would have guessed that she was to be one of the most generous benefactors that Bungay has known. Her only indications of wealth were the 1920s detached house in Outney Road, inherited from her parents, and a beach hut in Southwold, but the latter was dilapidated and in need of repair, and had been purchased by her parents in the 1930s, on the Gun Hill site, for around £100. When it was sold, following her death, it fetched £80,000.

Kathleen was born in 1914, one of four children, and her father Hubert was a director and works manager at Clay's printing works. Kathleen was educated at St Mary's School, and was employed as a secretary with an architects firm in Norwich. She never married, and didn't mix much socially in the town, but became a keen member of the golf club on Outney Common, serving as the ladies team captain.

She regularly attended the Sunday morning church services at St Mary's with her mother. When the church was declared redundant in 1978, due to diminishing congregations, it was taken into the care of the Redundant Churches Fund,

Kathleen Bowerbank, front row, fifth from left, in a pantomime production, *c.* 1934.

later renamed the Churches Conservation Trust. A Friends of St Mary's group was formed to keep the church interior cleaned and well maintained, and organise events and fundraising activities. Kathleen became a keen supporter and was a well-known figure standing by the entrance gate selling bunches of flowers from her garden for the Friends benefit.

Another keen member of the Friends was Lily Luff, a district nurse and also a spinster, who organised the church cleaning rota. The two did not see eye to eye, and on one occasion had a serious quarrel when the feathers really flew! Miss Bowerbank decided that a decorated Christmas tree would provide an attractive festive feature in the church chancel. But for Miss Luff, Christmas trees were a relic of pagan idolatory, and should never be allowed in a Christian building. When she saw it on display, she recoiled in horror. Then she stomped home, fetched her axe from the garden shed, chopped it down, and dumped the trunk and branches in the churchyard.

Following this conflict, the two women never spoke again, just glared and gritted their teeth if they happened to come into contact.

Below left: Kathleen Bowerbank at the ceremony commencing the digging of the foundations for the new medical centre that she helped to fund, 2002.

Below right: Kathleen Bowerbank was awarded the MBE medal in 2005.

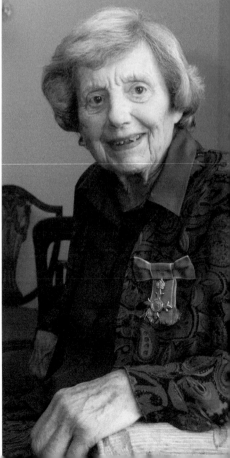

Kathleen's father and uncle had speculated in property in the 1930s, buying dozens of houses in the town during the national economic depression when prices were very low. On her mother's death, Kathleen inherited much of this property – by then worth a huge fortune, as well as money resulting from rents and sales – and was virtually the sole beneficiary.

She didn't let this new wealth change her life and continued to live as thriftily as possible. Instead she used it to benefit the town community. She contributed approximately £500,000 for the building of the new Bungay Medical Centre in St John's Road, and gave generous donations to Norwich Cathedral, and for improvements at St Mary's Church. She funded sponsorship for girls at Bungay High School to take up careers in engineering, and then £150,000 for the library building in Wharton Street.

In recognition of this generosity, she was awarded an MBE medal on 9 June 2005, which was presented to her at the Holmwood residential home, where she spent her declining years, by the Lord Lieutenant of Suffolk, Lord Tollemache.

She died, aged ninety-one, in 2006, and in her will left large bequests to both Norwich Cathedral and St Mary's Church. Her money had been well invested in stocks and shares and continues to produce a handsome income.

So – as somebody suggested – shouldn't the church be renamed St Kathleen's?

Interior of St Mary's Church, where Kathleen Bowerbank and Lily Luff assisted with cleaning and fundraising events.

Loyal and Constitutional Society

The French Revolution and Louis XVI's death by the guillotine in 1793 caused shockwaves throughout Britain.

In Bungay, a group of local gentlemen, landowners and shopkeepers met together on 4 June 1795. They were worried that insurgency could develop here and cause a threat to their properties and trades. They formed themselves into the Bungay Loyal and Constitutional Society and commenced regular fortnightly meetings with the aim of providing 'an antidote to Republican tendencies and as a means of Jollification'. Rather an odd mixture of ideals in such troubled times!

With increasing fears of French military expansion, as well as local unrest due to hardship caused by poor harvests and high bread prices, the society decided to

Engraving of the Battle of Waterloo, resulting in the defeat of the Napoleonic French forces in 1815.

establish its own militia. The first corps was enrolled under the command of Francis Bedingfield of Ditchingham Hall, with Robert Sheriff and Daniel Bonhote as his lieutenants. These men, together with sergeants, corporals, a chaplain and a surgeon, were in command of a troop of sixty privates.

Later, the government encouraged larger local defence forces to resist French invasion, and it was agreed that 'any persons residing in the neighbouring parishes be permitted to join providing they come properly equipped'.

By 1802 three companies had enrolled and were formed into a battalion. The troops did their training on Outney Common, and were provided with a smart uniform of scarlet and black. Samples of the fabrics still survive in the Ethel Mann Scrapbooks, in the Lowestoft Record Office.

Apart from their regular business and social meetings, the society also arranged an annual celebration in the upstairs of the Fleece Inn. A special dinner service was used, and a large mug survives, on display in Bungay Museum. It bears the inscription: 'Bungay Loyal and Constitutional Society, established June 4, 1795', with an emblem of a lamb and a fleece. Much drunkenness and joviality ensued as the mugs were filled with copious quantities of strong ale, provided by Matthias Kerrison, who owned several local breweries, and loyal toasts were drunk to king, country, and the grand old town of Bungay.

As the threat of an invasion by Napoleon Bonaparte's forces grew, mothers often warned their young children not to misbehave, 'else Boney ell get yew!' But the children could now slumber peacefully at night, knowing that with brave strong volunteers to protect them, Boney wouldn't be 'getting 'em'.

Gradually, as the threat of invasion declined, the need for local militia groups fizzled out. The society continued its 'jollifications' for a few more years, but they and their volunteer forces were eventually disbanded in April 1813.

Below left: Emperor Napoleon Bonaparte – 'Old Bony' as the British dubbed him.

Below right: Mug commemorating the Bungay Loyal & Constitutional Society, 1795.

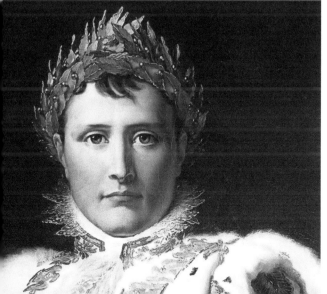

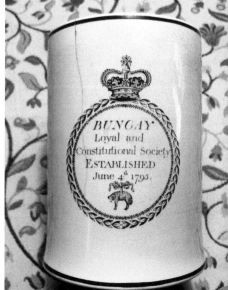

Mayfair – Maypole Dancing

Maytime was a particular period for celebration in earlier centuries, because it heralded the end of the long severe winters that predominated – very different from the milder winters we usually experience today. The warmer weather and longer days made everybody feel more relaxed, and food was more plentifully available after having to survive on preserved salted meat and fish throughout the winter, no fresh vegetables or fruit, and quickly diminishing stocks of corn for bread.

The main festival for celebration was Pentecost, Whit Sunday, the seventh Sunday after Easter. In Bungay this weekend holiday including the Monday was celebrated in Tudor times with the Church Ale Games. It was an event in which nearly all the parishioners were involved, in one way or another, and included a lavish feast with copious quantities of ale, music and dancing, and a play performance usually with a biblical theme. It was usually held in the churchyard of Holy Trinity, which at that time formed part of St Mary's churchyard, so there was plenty of space, and was organised to raise funds for the church. In 1566 the proceeds were used to fund a new church bell – a very expensive item.

In 1568, the event was held in the Castle Yard, probably because some of the churchwardens, who were Protestants, objected to merry making in the vicinity of the church, which could lead to drunkenness and unruly and lascivious behaviour. The expenses for food in the churchwardens accounts indicate how lavish it was:

5 calves, 9 lambs costing – £3 *8s 4d*
3 quarters of veal and 4 stone of beef. – *4s*
13 and a half barrels of beer – £4. 11s *7d*
A gallon and a pint of honey – *3s*
29 and a half gallons of cream – 18s *10d*
16 lbs of raisins, currants and saffron for puddings and cakes – *5s*
And 200 eggs – 3s *2d*

The first day of May was not celebrated as a Church festival, but there had been a long tradition of welcoming in the merry month of May.

The great B Play.

Dancing round the MAY-POLE.

WITH Garlands here the May-Pole's
 crown'd,
And all the Swains a dancing round
Compofe a num'rous jovial Ring,
To welcome in the chearful Spring.

RULE *of* LIFE.

Leave God to manage, and to grant
That which his Wifdom fees thee want.

B 4 TAW.

Lads dancing around a maypole
from an eighteenth-century
engraving.

> The young maid, who on the first of May
> Goes to the fields at break of day,
> And bathes her face in dew from the lea,
> Will ever after lovely be'.

A Suffolk custom in local farmhouses was that the first servant who brought in a branch of hawthorn – may blossom – on the 1 May, would be rewarded with a dish of cream.

An old verse that was recited goes:

> This is the day,
> And here is our May,
> The finest ever seen,
> It is fit for the queen,
> So pray, ma'am give me a cup of your cream.

The farmer's wife was pretty sure she wouldn't be doling out cream, for it's very unlikely to find the hawthorn in bloom so early in the month.

A converse superstition that prevailed was that if you bring may blossom into the house, you will die before the year is out, and:

> Sweep with a broom that is cut in May,
> And you'll sweep the head of the house away.

The tradition of dancing around the maypole dates back to 1554 (the earliest recorded reference, according to the Oxford English Dictionary), a high narrow pole that is painted with spiral stripes in different colours, decked with flowers and hung with ribbons. Like the Ale Games, it had to be in a large open space, probably in the churchyard, or the Castle Yard if the church authorities got sniffy.

At the Bungay Council School, in Wingfield Street, Lilian Trafford was appointed headmistress in 1944. She was a keen enthusiast for traditional folk dancing and introduced it into the curriculum. In particular she revived May Day celebrations, with pupils dancing around the maypole, and a boy and girl pupil crowned May King and Queen, dressed in ceremonial robes and seated on a throne decorated with branches and blossoms. The event was held in the large garden of The Mounds, in Lower Olland Street, and parents, local dignitaries and other guests were invited to attend.

It is sad that the school celebration eventually ceased, and there is no maypole dancing in recent times. For what better way is there to celebrate the coming of the long warm days of summer?

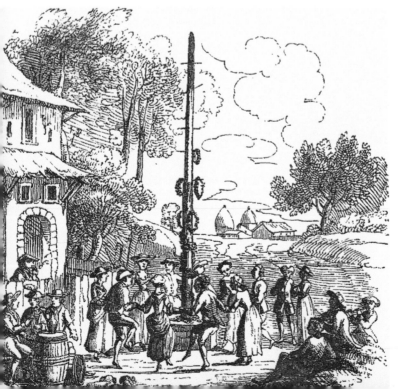

A country maypole, *c.* 1850.

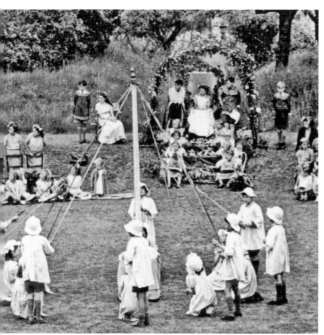

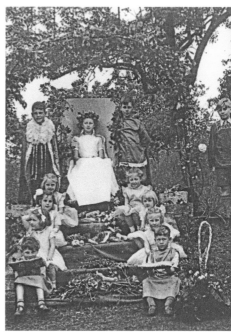

Above left: Pupils of Bungay Primary School maypole dancing in 1948.

Above right: The May Day Queen, Pam Knights, and her attendants.

Below: May Day circle dancing.

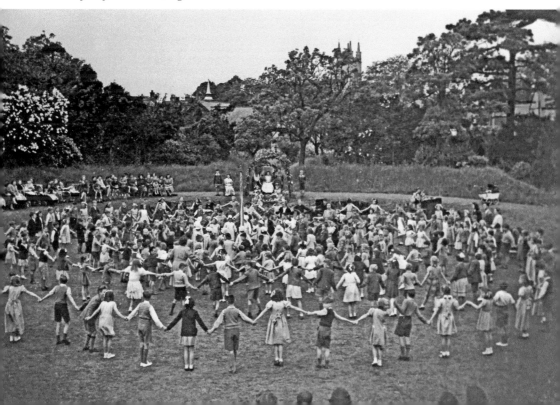

National School

There was no schooling available for children of poor families before the Victorian period. This was to the advantage of their parents, as it meant that as soon as they were old enough (i.e. around five) they could help with household chores. The boys would collect and chop firewood, and water from the wells or rivers, and go fishing or rabbiting with their dads, and the girls assisted their mums with cooking, washing and cleaning, and looking after the babies and younger children.

Children from more prosperous families were educated at the Grammar School, established in 1565, if they were boys, and by the Georgian period various schools were available for girls who were taught mainly needlework, music and dancing. All these were fee-paying academies.

The girls' schools were generally short-lived, but in 1885 the two Miss Maddle sisters established a boarding school for girls in a small building in Earsham Street, which flourished so well that they were enabled to move to much larger premises in

Pupils at Miss Maddle's School for Girls, 1886.

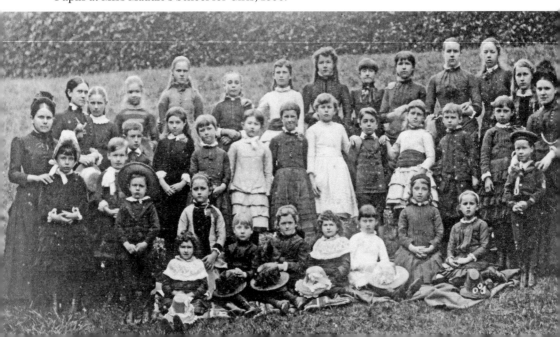

Trinity Hall, near the church. Then in 1891 to Linden House on the corner of Earsham Street and Outney Road. It provided both day school and boarding accommodation for girls aged five to eighteen, and a preparatory education for boys to the age of eleven. Pupils were entered for the Cambridge Local Examinations, and the school gained an excellent reputation. It continued as a boarding school until 1945, when it was taken over by Miss Maudsley and Miss Doble, and finally closed in 1966.

Linden House was situated adjacent to Bungay Grammar School, and it can be imagined that there was quite a bit of flirtatious interest between the older pupils, with the boys occasionally clambering over the wall into the girls' school garden, love notes poked through chinks, and kisses blown from the schoolroom windows. On one occasion a cricket match between the pupils was organised on the nearby Outney Common. The boys easily won, but the girls put in a creditable performance considering they had never played before.

Since the eighteenth century horse races had been held on the Common, attracting thousands of visitors every year for the annual event. It was usually organised in the spring months, and all the townsfolk who could manage it would attend with many of the shops and businesses closing. School pupils were also given a two-day holiday in order to attend, and we can guess that this might be another opportunity for the Grammar Grubs and the St Mary Madonnas to surreptitiously meet up on the race ground – if they could escape their teachers' or monitors' supervision.

The Grammar School vacated the premises it had occupied for more than 350 years in 1925 and transferred to purpose-built premises with very large playing fields in St John's Road, on the outskirts of the town.

This was a sad day for the girls, and life was never so much fun again once their entertaining neighbours had moved away.

The first establishments for poorer families were the National Schools for children and infants established by the ecclesiastical authorities in 1834 and designed to

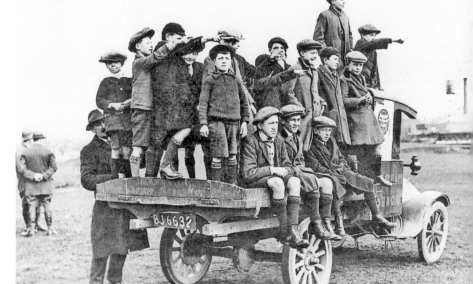

Lads at annual race meeting – pupils were given a two-day holiday so they could attend – c. 1925.

instil the precepts of the Church of England, at a time when independent chapels – Methodist, Baptist and Congregational – were on the increase.

John Barber Scott was a keen supporter of the National Schools and took an active part in establishing one in Bungay when the plans were first announced. He was Bungay's wealthiest resident, having inherited the fortune his father made from his tanning industry. Born in 1792, he had kept a diary from the age of around seven

Left: Bungay Grammar School, Earsham Street, *c.* 1900.

Below: St Mary's Boarding School for Girls, Earsham Street, *c.* 1920.

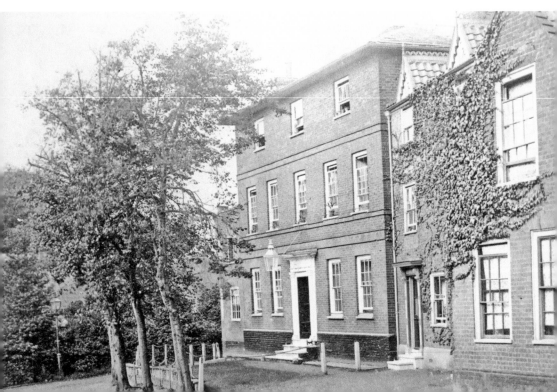

and continued it for the remainder of his life, recording events in the town and his frequent travels abroad in Europe.

On 26 August 1833, he first records discussions concerning the new school. By 11 September leading men in the town had collected £120, and Scott and Revd John Cobb, vicar of St Mary's Church, were appointed secretaries of the school committee. It was decided that there should be one building for infants and a larger one for older pupils. The Bishop of Norwich pledged financial support, and the Lords of the Treasury agreed a grant of £181 to help fund both schools.

On 18 November a temporary room was provided in a large private house for the infants' education. A female school mistress and assistant were appointed, and nineteen children between the ages of three and six commenced their schooling.

A plot of land was later acquired on the Lord's Piece, adjacent to Outney Common, for the National School and Scott records the foundations being dug on 13 May 1834.

On 24 June he records: 'the children from the Infant School, thirty six in number, come with their teacher to sing and recite before Charlotte, Miss Butcher, [Scott's family relatives], and Cobb [curate of St Mary's]. Afterwards they play in the garden and have tea and cakes in the kitchen'.

In August Scott was busy superintending the erection of the National School, and on 8 September records: 'This day was opened the Infant Department of the Bungay National School in the newly built School House opposite the Drift. 101 children under the age of seven were admitted.'

Bungay Council School was the first non-denominational school for boys and girls, opening in 1877.

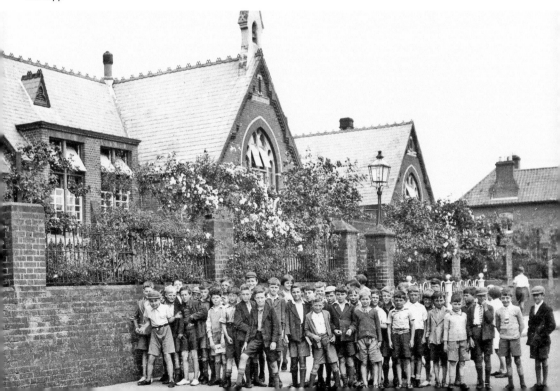

On 15 September the school buildings for older children were completed and eighty boys and forty-two girls were admitted. Scott commented: 'Our new Master, J. Abel, appears to be a great disciplinarian. Terms – for one child 2d per week; for every additional child 1d. To be paid every Monday morning. Sittings in the Church for the children have already been arranged with the churchwardens'.

The diaries cease from December 1834 for four years, so no further information is available from Scott about the progress of the schools.

In 1835, the British & Foreign Bible Society established a school in Plough Street (later named Wingfield Street), which was financed with a grant of £150 from the government. Then in 1870, the Liberal government passed an Act to provide board schools, so that education would be available for all children between the ages of five and twelve. However, children were not obliged to attend them until 1880, and their parents had to pay fees until 1891.

The buildings in Wingfield Street were erected in 1877, and are still in use today, with large extensions added to the rear. Pupils were divided into separate classrooms and play yards for the boys, girls and infants.

The British & Foreign School was no longer needed and was sold in 1882 and demolished. The boundary walls can be seen on either side of Virginia House and Rose Villa, which were built in the 1890s.

The National School continued until around 1880, and was then demolished and the row of attractive terraced houses named Waveney Terrace built on the site, adjacent to where the St Edmund's Almshouses were built in 1895.

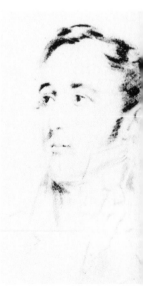

Above left: Outney Road, depicting the area occupied by the National School, later demolished and the St Edmund's Almshouses built nearby.

Above right: John Barber Scott (1792–1862), town reeve and a wealthy philanthropist.

O

Old Poll

Eleven o'clock has just chimed. Time to have a break from writing my book and have a reviving mug of coffee, with maybe a chocolate biscuit if I'm feeling self-indulgent. What an orderly household Old Poll maintains, with his distinguished presence, efficient time-keeping habits, and commanding tones. Just as he has been doing now for nearly two centuries!

'Old Poll', as I like to nickname him, is a long-case clock made by Philip Poll in the Regency period. He was one of a family of horologists, makers of clocks and watches,

Bridge Street, Bungay, *c.* 1900

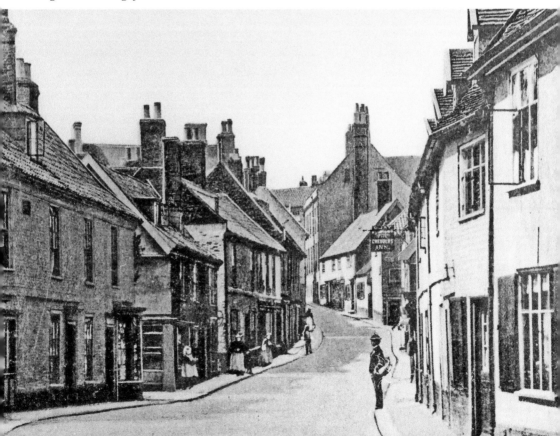

and son of Robert Poll of Wissett near Halesworth, who later moved to Norfolk. Robert died in 1815, when his will describes him as Robert Poll of Metfield, son of another Robert who had a clock business in Harleston. Philip was born in 1775, and, having learned his father's trade, set up in his own business in Bungay. An advertisement in the *Ipswich Journal*, 21 November 1801, states: 'Apprentice wanted by P. Poll & Co., Bridge Street, Bungay'. This indicates that he already had other assistants, one of them perhaps his son Robert, who, in an 1839 trade directory, is recorded as a watch and clockmaker of the same address. So it seems that Robert took over the management of the workshop when Philip grew old, and then died in 1846.

Bungay was a prosperous market town and was able to accommodate a number of clock and watchmakers, and more than twenty flourished in the eighteenth and nineteenth centuries. Bridge Street, close to the river and the busy Staithe navigation, was one of the principal shopping thoroughfares, and several clockmakers established businesses there in the Georgian and Regency periods, including William Field, Edward Mills, and Enoch and Richard Carley. Some of them were superb craftsmen, and William Field advertised in the *Ipswich Journal*, 6 October 1750, that he was newly established, and 'designs to sell, make and mend Clocks and Watches as neat as in London'.

Below left: Long case clock made by Philip Poll, early nineteenth century.

Below right: Long case clock made by Philip Poll, *c.* 1820.

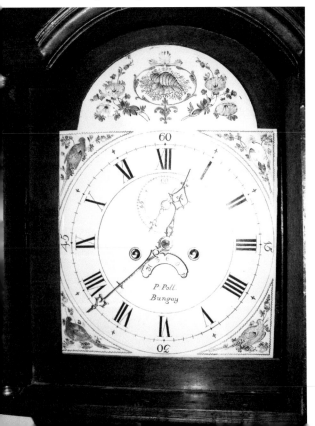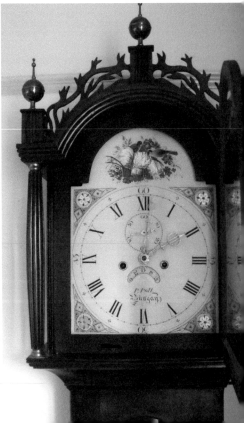

Bridge Street had also been connected with the tanning and leather trades from medieval times, which greatly contributed to the town's prosperity.

One of my reasons for buying a clock by Philip Poll was because my ancestor, John Rising Reeve, had a tanning and shoemaking business in Bridge Street at the same time that Poll and his family were there. I like to think that the two families were friendly, that Philip and John supped pints of ale and mardled together about trade and profits in the Chequers pub, while their wives sipped China tea at home in the front parlour and discussed the latest bonnet fashions.

Perhaps John purchased a fine clock from Philip similar to my own, and the little Poll siblings had their boots and shoes made by John Reeve. At Christmastime the two families might stroll the short distance together to church, through the snow-filled streets. In death, some of them were as close neighbours as in life, for they are buried only a few yards apart in St Mary's churchyard, where their names can still be deciphered on the worn and crumbling gravestones.

Printing Press Choir

John Childs managed the printing works, now Clay's, in partnership with his son Charles in the nineteenth century. Charles was very fond of music and organised a choir formed of the printing work employees. They had regular practice sessions in the evenings, and performed publicly twice a year in concerts in the Corn Hall in Broad Street, formerly the Fisher Theatre.

One visitor to Bungay who greatly enjoyed these performances was Edward FitzGerald (1809–83), the writer now best known for his translation of the Persian *Rubaiyat of Omar Khayyam.*

Fitzgerald was born into a wealthy family and lived near Woodbridge, but often visited Geldeston Hall, near Beccles, the home of his favourite sister, who was married to John Kerrich, a local squire.

During one of these visits, FitzGerald became acquainted with John Childs. They became friends and Childs published several of FitzGerald's early poetic works. FitzGerald also established a warm personal relationship with Charles, closer to him in age, and described him as 'a Man of Sense, of great Probity, Candour and Honour'. They shared a deep love of music and 'FitZ', as he was known, developed an enthusiastic interest in the Printing Press choir. Writing to a friend in 1850, he describes his activities in the Beccles area, and adds: 'sometimes I go over to a place elegantly called Bungay, where a printer lives who drills the young folks of a manufactory there to sing in chorus once a week – If you were here now we could go over and hear the Harmonious Blacksmith sung in chorus, it almost made me cry when I heard the divine Air rolled into local harmony from the four corners of a large hall'.

'FitZ' even got involved in helping with the productions, describing how he was 'dilettante -ing it over Purcell's King Arthur, helping to put it in trim to be trumpeted by some manufacturers at Bungay ! I only hope we shan't spoil so grand a thing among us'.

The choir consisted of eighty singers and thirty instrumentalists, and with audiences exceeding 300, it is astonishing that the hall, now the Fisher Theatre auditorium, could hold so many people.

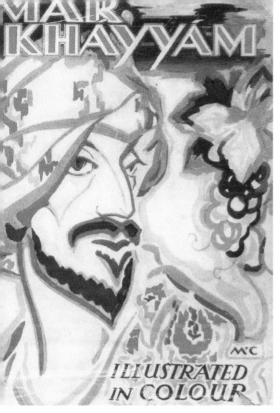

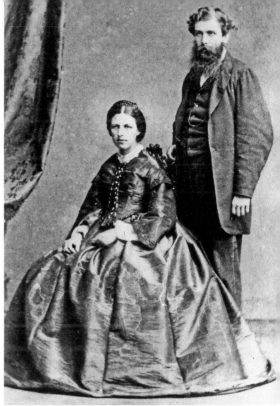

Above left: Cover illustration of an edition of the *Rubaiyat of Omar Khayaam*, illustrated by Otway McCannell, *c.* 1930.

Above right: Charles Childs, Bungay printer, with his wife, *c.* 1870.

Below: The Fisher Theatre, built in 1828, and later converted for use as a Corn Hall, *c.* 1850.

'FitZ' continued to have some of his books printed by Charles, after John Childs died in 1853, and the second, revised edition of his *Rubaiyat* was issued in 1868.

It's wonderful to know that Bungay not only provided the lonely and often depressed poet with the warm friendship of the Childs' family, but that they were also instrumental in promoting one of the world's best-loved poems. FitzGerald lies buried in Boulge churchyard, near Woodbridge, but his ghost will remain humming a cheerful tune from Purcell around the old theatre in Broad Street.

Interior of the Corn Hall, formerly the Fisher Theatre, *c.* 1865.

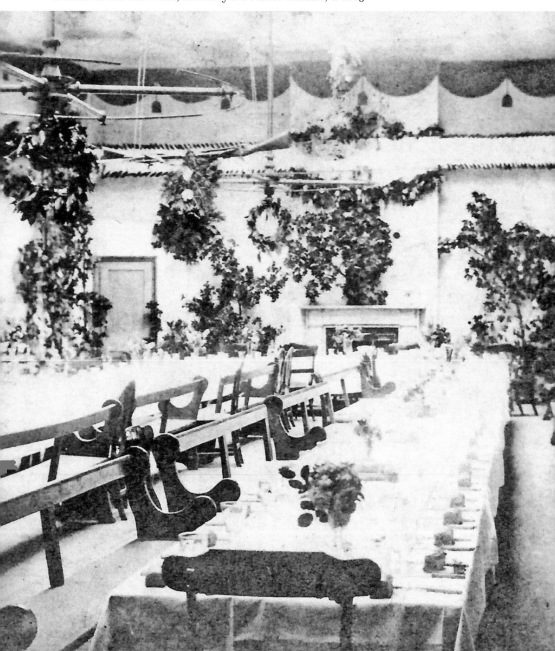

Queen's Head Pub and the Queen

In the nineteenth century, Bungay had two pubs named to celebrate the reign of Queen Victoria: the Queen's Head in Trinity Street and the Queen in Upper Olland Street. They catered for different clienteles: the one in the town centre was upmarket for prosperous traders, and the other, much smaller, served local householders in the long street stretching out of the town.

Before Victoria's reign, the Queen's Head was known as the Norfolk Arms. It's recorded in Pigot's Directory of 1830, when it was managed by Robert Chase, who had a butcher's business alongside it in the area established for butcheries and slaughterhouses, known as the Shambles. The butcher's business continued for

The Queen's Head Hotel, corner of Trinity Street, *c.* 1920.

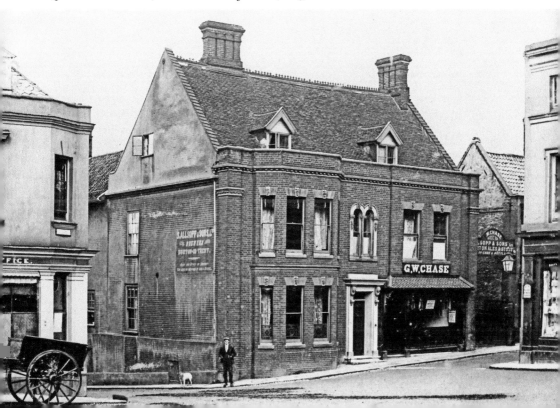

much of the century, later managed by James Frew, and there are photos of the shop frontage displaying a wide variety of carcases in the street for the Christmas trade.

The Queen's Head was a smart hotel as well as an alehouse. The imposing frontage was painted white, with a large semicircular bay window to the front room, the private bar for guests, and a billiards room beside it. The public bar and off-licence was entered round the corner from No. 2 Bridge Street. In 1898, its annual rates were £35, making it the fifth most prosperous establishment in the town after the King's Head (£99 per annum), Three Tuns (£44), the Fleece (£42) and the Angel in Lower Olland Street (£38).

There was a steep decline in the pub trade by the beginning of the twentieth century and the Queen's Head closed in 1913. It was later converted into the National Westminster Bank and is currently a charity shop.

The Queen pub stood adjacent to Turnstile Lane. This part of Upper Olland Street was jokingly referred to as 'Pub Alley' because it had four pubs in close proximity: the large Rose & Crown, where the original sign still survives; nearby, No. 20, a small 'front-room' alehouse; the Greyhound; and in the Georgian terraced row opposite, the double-fronted Red Lion.

The Queen pub was quite large and provided accommodation. There is little information about it, but in 1898 its annual rates were £19, indicating that it was one

Displays of meat in Chase's butcher's shop, adjacent to the Queen's Head Hotel.

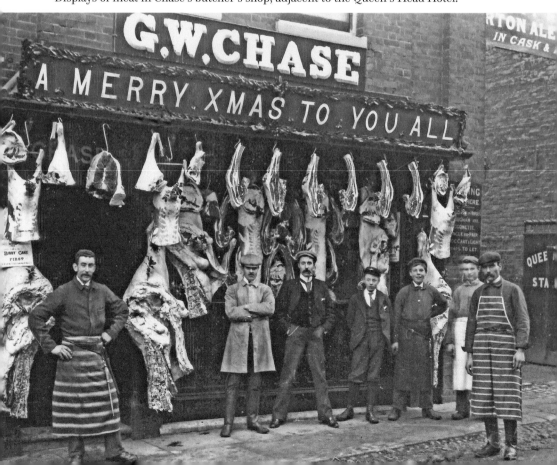

of the more prosperous establishments outside the town centre. It closed in 1909, and in recent years was a cycle-repair shop, and then converted into flats.

Queen Victoria's Golden and Diamond Jubilees, commemorating her long reign, were celebrated with loyal enthusiasm in the town centre. On both occasions, in 1887 and 1897, the Market Place was crammed with hundreds of people, and the local troops of the Norfolk Volunteers Regiment fired a loyal salute. Their brass band also struck up a joyful chorus of 'God Save the Queen', sung by pupils from the local schools and the Sunday school. The children were then marched in crocodile formation to the Recreation Ground on Earsham Dam, where sports and entertainments were organised, and a hearty tea of chunky sandwiches, fruit cake, lemonade and ginger beer was provided.

In the evening many of the adults congregated in their local pubs, and we can be sure that an especially loyal toast was drunk by those in the Queen and the Queen's Head bars to their esteemed sovereign.

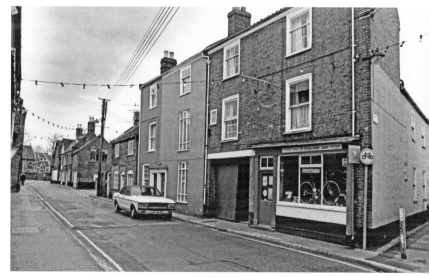

Right: The Queen pub in Lower Olland Street, later used as a cycle shop, in the 1970s.

Below: Children playing in Lower Olland Street. The Queen pub is on the left at the rear of the photo.

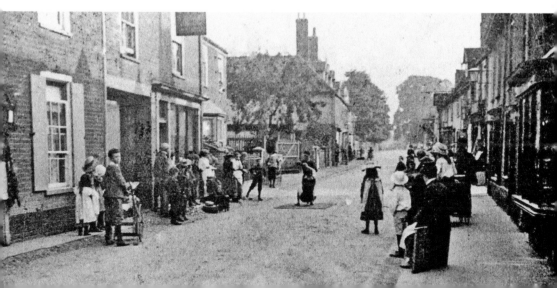

Railway

Shops and businesses in the town have changed or disappeared with alarming regularity in recent times. Going further back, how many people remember the Mayfair cinema with its art deco façade and curved entrance steps in Broad Street? Or Taylor's Engineering and other industrial sites in Nethergate Street? The Watts's Garage in Bardolph Road was demolished around a year ago, and very soon the Community Centre in Upper Olland Street, which has been the venue for so many lively events and celebrations, will be nothing but dust in the soil for worms and moles to crawl through.

There can be few but us 'old-uns' that remember the railway station at the end of Outney Road. I have two particular memories of it from the early 1950s: meeting my elder brother Robin from the train on his return from staying with a friend in Pulham Market, and every Saturday trotting down to collect my Enid Blyton *Sunny Stories* magazine from the WHSmith's bookstall.

A train approaching Bungay railway station, *c.* 1930.

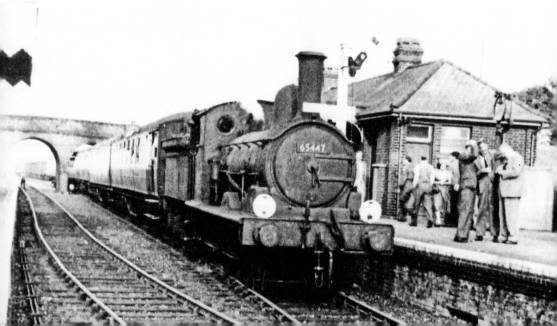

For around ninety years the station played an important part in Bungay life. The Harleston to Bungay railway line opened in 1860, and the Bungay to Beccles link was completed in 1863, finally incorporating the Waveney Valley towns into the Great Eastern Railway network. In 1865, there were four weekday trains in each direction between Tivetshall and Beccles. By 1915 the number had reached a peak of eight over the full length of the branch line. The later years of the Second World War led to an increase of traffic on both the passenger and freight lines, because strategic military installations were situated in our area.

Outney Road is now a comparatively quiet end of the town, but a century or so ago it was busy and bustling with horse-drawn carriages, motors, and cycles. Train passengers hurried along with suitcases, barrow boys provided goods and services, and the King's Head, the major hotel, organised transport to the station for the benefit of its guests. The trains were also used by school pupils, who attended the Sir John Leman School in Beccles, and those who travelled from the villages to the Grammar School and St Mary's School, Earsham Street. The boys often annoyed the residents of the Cherry Tree pub, near Scales Street, by aiming screwed-up sweet wrappers through the open windows as they scampered past.

By the middle of the twentieth century, with the growth of motor traffic, the station fell into decline. Travellers preferred the cheaper and more direct new bus and coach services. The passenger station closed in January 1953, and the goods station struggled along until just before the closure of the whole line in 1966.

If the station had survived, Clay's could continue to have goods delivered to their doorstep by rail, rather than by road – quicker and cheaper. Now, the whole complex of buildings, which provided both economic and social benefits for the town, has disappeared. Virtually nothing to indicate or commemorate where it once stood.

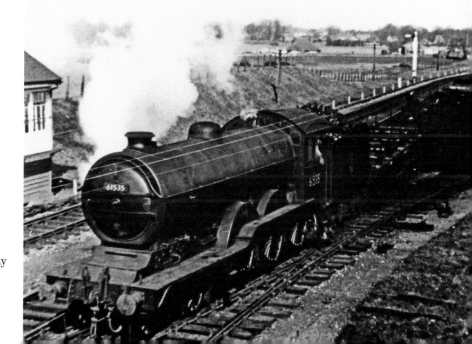

A train, billowing steam, entering the goods yard, Bungay station.

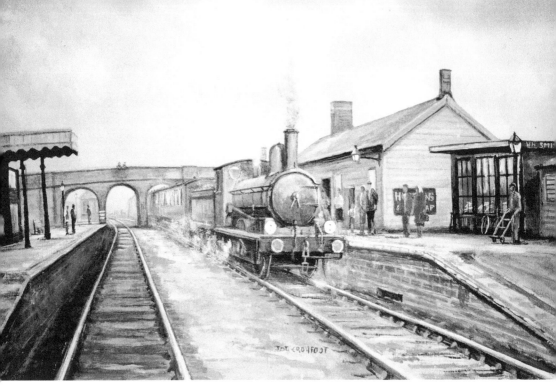

Above: An oil painting by Joe Crowfoot, *c.* 1980, depicting Bungay station as it was in the 1930s.

Below: A commemorative colour print issued in a limited edition in 1983, when a road bypass was constructed adjacent to the former railway track.

S

Swan Lake

Swan Lake, with the supremely magical and heart-rending score by Tchaikovsky, is my favourite ballet, and I have attended many performances of different productions over the past thirty years at Covent Garden and elsewhere.

So each winter I am thrilled to experience a different presentation of the theme from my own bedroom window.

Let me explain. The upstairs windows of my house provide an extensive view over the Waveney water meadows at Earsham. During the winter, when the trees are bare and the view is unimpeded, the meadows frequently flood, often for several days or even weeks at a time. Swans congregate, dozens of them, on the shallow and glassy mirror surface, which changes colour according to the weather and the time of day,

However, it's at its most beautiful at sunset, when the light begins to fade, the sun sinks in swathes of pink and golden ribbons and mauve and rose-tinted clouds, and a silver crescent moon creates an ethereal presence in the sky. All this is reflected in

Corps de Ballet performing in Tchaikovsky's *Swan Lake,* Russian State Ballet of Siberia.

the flood waters, upon which the swans are gently drifting, with their graceful slender necks uplifted, or curving down to dip their beaks into the water.

The scene, so much like the lakeside where Prince Siegfried first sees the vision of the enchanted Swan maiden, who he is doomed to love, little knowing that she is gripped in a curse that will finally end in tragedy for both of them.

Left: Distant swans floating on the River Waveney floods, photographed by Adele Goodchild, *c.* 2018.

Below: Swans and cygnets by the River Waveney in Bungay, photographed by Martin Evans.

Tudor Church Carpenter: Edward Molle

The mid-sixteenth century was a troubled and tempestuous time for church congregations, when communities were in fierce conflict between those who supported the new Protestant beliefs and revised forms of worship and those traditionalists who were anguished by the rift with the Catholic Church in Rome – and all that they and their forbears had revered for generations.

Henry VIII had established the Church of England, after severing connections with the papal church of Rome, and it was his son Edward VI, who, in 1547, introduced legislation for all parish churches to introduce the new Protestant forms of liturgy, and the Bible in English, and remove altars, stained glass, church furnishings, paintings and anything relating to superstition and idol worship associated with Roman Catholicism.

It was the role of Edward Molle, the chief carpenter employed at St Mary's Church, to bring these changes about. His work must often have made him unpopular with one or other of the factions. He probably suffered verbal abuse, and perhaps physical abuse as well, when parish members were enraged seeing him breaking up the old altarpieces and furniture and carrying away ancient carvings of saints and angels, and embroidered textiles and wall hangings, some for a bonfire in the churchyard. Some of these items would have been bequeathed by their own ancestors, and to see them wantonly destroyed was heartbreaking.

In past times, people were not nearly so wasteful as we are today, so it's likely that furniture, fittings and textiles may have been salvaged and adapted for other purposes. It's also likely that the strict Protestant churchwardens were keen to make parishioners aware that such relics were abhorrent and needed to be publicly destroyed.

The career of Edward Molle is well documented in the St Mary's churchwardens registers. In 1547 they record payments for breaking all the old stained-glass imagery and obliterating the wall painting of St Christopher with whitewash. The following year, Molle is recorded as making a lectern for the new English Bible to lie on, and he was also paid for removing the altarpiece, various carvings and statues, and making a Communion table.

In 1553 Mary Tudor, an ardent Catholic, succeeded to the throne. She immediately commenced getting the churches restored to their traditional appearance and uses. So poor old Molle was employed to reinstate the rood loft in front of the chancel, with its statues of St Mary and St John, restore the high altar, and new embroidered hangings and elaborate vestments for the priests were purchased. A number of Protestants were martyred during her reign.

She was succeeded by Elizabeth I in 1558, who was a strong advocate of the reformed religion and keen to restore peace and unity to the kingdom. So once again Molle, assisted by his two young sons, was ordered to remove the altar and rood loft, all Catholic imagery, and reinstate the Communion table.

How did he feel about all these changes? Whether he preferred the traditional forms of worship he had grown up with, or the radical innovations, he had to keep his mouth shut or risk losing a very lucrative position. But maybe when he knelt in prayer at church, or in the deep dark watches of the night he prayed to God for forgiveness If he had erred, fearing what all Christians feared in the period – punishment in Purgatory, or eternal suffering in Hell.

Fortunately other contracts poor old Molle was given were more satisfactory. In particular, he was responsible for the woodwork involved with hanging a new bell in Holy Trinity churchyard. Whereas St Mary's priory church had a belfry with a full

Interior of St Mary's Church, *c.* 1900.

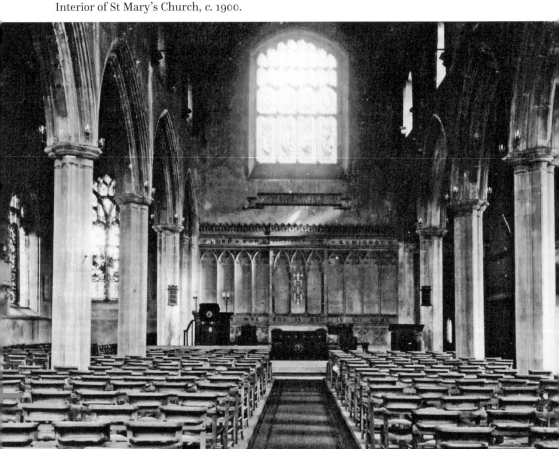

peal of bells, Holy Trinity only had a single bell used for summoning parishioners to daily prayer or Sunday services. In 1566 it was decided to purchase a new bell, and the churchwardens accounts record the various expenses connected with it. Local people sold their pewter cups and plates to be melted down to provide metal, and it was recorded that one hundredweight of pewter was collected, for which the churchwardens paid 26s in total. A bell founder was employed from Norwich, and he was provided with dinner in Bungay and given 20s when the contract was drawn up.

The total cost of the bell and its wooden hanging structure amounted to around £50, which was a colossal expense for the period. Church Ale Games – often rowdy occasions – were organised to help with the funding.

Edward Molle was told to ensure that all the woodwork would be completed ready for the bell to be tolled on Christmas Eve. He brought his young son John along to help him, and at the first practise tolling of the bell, all those who had assisted were given a meal of bread and beer.

It is clear that Molle had to work up almost until the last minute, because the parish accounts record: 'Paied to Molle and his sonne 2 daies work endyd on Christes Eve'. Even his younger son, Richard, aged twelve, was asked to help and was paid 12d 'for helping at divers times to saw'. They only just had time to change out of their sawdusty clothes and grab a bite to eat before rushing back to the church for the midnight Mass.

How proud Molle was when he at last heard the bell ring out loud and clear, and he was even more pleased with the extra money he and his sons had earned to make it a specially Happy Christmas.

A carpenter in his workshop – a bit later than Molle's period, but indicating the sort of equipment he used.

Urchins

The children of poor families could often be a social problem, especially the boys. Girls were usually kept at home, minding the babies and younger children and assisting their mothers with the domestic chores. However, boys could roam free when they reached the age of seven or eight, when they were not required to help their fathers, or do jobs such as tending livestock, carrying buckets of water from the well, or collecting and chopping wood for the fires. There was no education available for poor children until the National School was established in 1834, and much later the board schools in 1877, so some of them tended to roam the streets and get into all sorts of mischief and trouble.

There was a strong Christian feeling predominating in some well-to-do families that they should do their best to help the poor, and Bungay author Elizabeth Bonhote encouraged her two daughters to accompany her on visits to their homes, taking baskets of provisions and sometimes medicines as well. In one of my *Bungay Bitesize* articles I penned the following imaginative account:

> In one of the essays that Elizabeth Bonhote wrote in her book on education for girls, The Parental Monitor, 1788, she laments that there is a lack of charity for the poor at Christmas, as the wealthier families were no longer providing gifts of food. So, setting a good example herself, she set out with a basket of goodies on a frosty Christmas morning. Her daughters, Eliza and Susan, were obliged to accompany her, not best pleased at being dragged out of their beds at dawn, squealing and sulking as teenagers would today.
>
> Elizabeth led them through the snowy cobbled streets to the Castle, where several of the town's poorest inhabitants were living in hovels built up against the ruins. The first door they knocked at was opened by a ragged old woman, and the stench from the dark interior was so nauseous that Susan ran behind the wall and was sick in her handkerchief. 'Suppose she's got the Pox and we both die a horrible death', she whispered to Eliza, so they kept their distance from the doorways. Mrs. Bonhote remained kindly and cheerful, handing out loaves of bread, mutton pies and cheeses to every household. Surrounded by pinch-faced spotty urchins,

she patted their greasy locks, coo-cooed to the babies, and handed her largest, reddest apple, to the little cripple, Jacko.

'Yer a bloomin'Angel from 'eaven', cried the boy. Eliza and Susan soon grew more cheerful, seeing what comfort their gifts had provided, and commenced singing a tuneful Chistmas carol as they trudged home past the snow-domed Butter Cross.

Towards the end of the eighteenth century, an initiative developed for providing Sunday school education for children from poor families, whose parents were unlikely to attend church services. Robert Raikes commenced the scheme nationally in 1783, and by 1785 several Sunday schools were started in Norwich and the region. Thomas Miller, who was a churchwarden at St Mary's, welcomed the scheme for Bungay. At a town meeting in December 1785, he recommended an appeal for funds from the chief residents to get a Sunday school established in the town. A sum of £22 5s 8d was speedily raised. In March a committee was formed, and later in the year the first scholars were admitted, totalling 100 boys and girls by the end of 1786. Collection boxes in St Mary's Church accumulated £2 15s 6d, 'which was appropriated to small pecuniary awards to those who constantly attended, were Docile and Tractable in their behaviour, and made the greatest proficiency in their Learning'.

Boys band taunted by urchins in the Market Place.

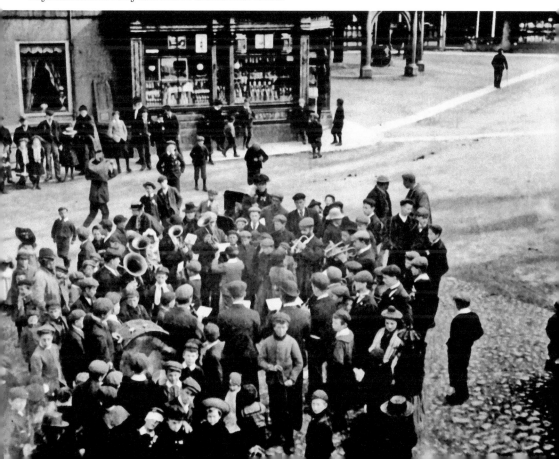

This prosperous beginning occasioned a marked change in the behaviour of the children, 'who from being filthy, Dissolute and Vicious in the Extreme, became Decent, orderly and attentive and began to have some sense of Religion and of a Due Subordination to their Superiors'.

Subscriptions from benefactors increased to £29 16s 6d in 1787 and the number of scholars increased to 120. On the first Sunday of every month thirty-two of them were rewarded with 3d each, those who had learned to read were given prayer books, and those who had progressed sufficiently to be able to assist the master or mistress were presented with bibles.

In August of that year, the children gave a public performance: 'an anthem composed for them by Mr. Holder, the organist, from the 11th, 6th, and 3rd verses of the 34th Psalm, was sung by the Sunday School children in a very pleasing manner at St. Mary's Church'.

The event was mentioned in a letter written to the *Norwich Mercury* newspaper:

On Sunday last in the afternoon, an Anthem was sung by the poor children of Mr. Spilling's Sunday School, to a very large congregation; and so affecting were the voices of this infant company of performers, as to draw forth the tears of many persons present. These poor infants but a few months since spent the Sabbath in all manner of idle diversions, profaning the name of Him who gave them existence and living in open rebellion against their Redeemer. They are now (Happy Change!), snatched from the broad road of destruction and placed in the path of virtue...

Idle lads gazing at the cameraman in St Mary's Street.

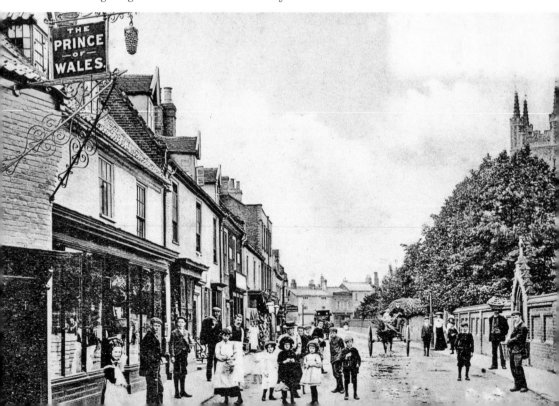

Thomas Miller, who established the first Sunday school in Bungay and died in 1804.

So Thomas Miller's initiative had proved a success, but it does make us wonder whether the majority of the children resented being subjected to learning on the only day of the week they had free, if they were in paid employment. And, even if they enjoyed it, they were at the mercy of parents who would soon forbid attendance if it interfered with the chores children were needed for at home.

However, for those who were bright and permitted to continue, learning to read and write was a real boost, enabling them to improve their circumstances as they grew to become adults.

Children from poor families could often end up with their parents in the dreaded workhouse at Shipmeadow, near Bungay – or the 'House of Industry' as it was grandly known – when it opened in 1767. It was one way in which the parishes of Bungay and Beccles could reduce the number of urchins in the streets causing trouble. James Kemp was born illegitimate in the workhouse in 1771, and was rarely allowed out because children could only leave when they were old enough to gain employment. But James had a feisty spirit and was often in trouble. In December 1782 the workhouse governors reported that he had stolen 3*d* from an inmate and escaped into town. He was captured and brought back the same day, and as a punishment

Page heading depicting Knowledge, from the *Towards the Light* art magazine edited by Joseph Bibby, 1932.

was beaten and had his leg 'clogged' with a large lump of wood to prevent further escapades. However, within a few months he was off again, scaling the 10-foot wall, and throughout 1783 there was a pattern of escapes and punishments.

However, on one of his adventures, he had the good fortune to meet up with a Yarmouth chimney sweep, who offered the governors to take him on as an apprentice. They were only too pleased to be rid of their troublesome truant, but even before the indentures were signed, James had sped off again to embrace his new life of freedom.

So this story of one of the many deprived children of the period seems to have had a happy ending. He never reappeared in the Shipmeadow records, so let's hope that the kindly chimney sweep provided him with a good home and a secure future.

Volunteers and Sir Charles Vere MP

Bungay Museum has recently been donated a nineteenth-century poignant letter, which conveys a heart-rending family issue in the space of just a couple of paragraphs.

The letter is written on a small, thin piece of yellowed paper, penned in ink, faded brown in exquisitely neat handwriting.

It is headed 'Bungay, 29th June, 1840', and addressed to Sir Charles B. Vere, MP for London – at that time, if you were an MP no further details of address were required, as the post delivery boy would quickly convey it to the correct office at Westminster, and free delivery was available for parliamentary mail.

Honored Sir,

Some time since we took the liberty to trouble you through a Gentleman near Southwold to endeavour to obtain for us the discharge of our only child 17 years of age who more than a year ago enlisted with a recruitment party at the 77 Regiment here.

We understood that when the number of men was sufficient the discharge might be obtain'd upon payment of £20 which with great difficulty we have obtain'd and shoud be most thankful if Your Honor would inform us whether his discharge can be now allowed as if it can we should consider it a great blessing – our child was with the depot of the Regiment at Hull when we last heard from him.

We are honor'd Sir

Your obliged humble servants
James Moor
Phebe Moor

The letter has no punctuation other than a full-stop at the end of each paragraph.

Bungay 29th June 1840

Honored Sir,

Some time since we took the liberty to trouble you through a Gentleman near Southwold to endeavor to obtain for us the discharge of our only child 17 years of age who more than a year ago enlisted with a recruiting party of the 77 Regiment here.

We understood that when the number of men was sufficient the discharge might be obtain'd upon payment of 20 £s which with great difficulty we have obtain'd and should be most thankful if your Honor would inform us whether his discharge can be now allowed as if it can we should consider it a great blessing – our child is with the depot of the Regiment at Hull when we last heard from him

We are honor'd Sir

Your obliged humble Servants

James Woor

Phebe Woor

Letter written by the Moor family requesting the discharge of their son from military service.

On the reverse of the paper is the following note, in another hand:

Reydon, Sunday afternoon
Mr. Moor
Pray write what I have written on the inside of this upon the sheet of paper which I send ruled and when written send it to me. Sir Charles thinks the application should come from you and your wife.
 Direct it to him but send it to me and not to him. I wrote to your son.
<div align="right">Yr. honble. Servt.
J. Jermyn.</div>

It would seem that recruiting officers were visiting Bungay and other local towns in 1838–39 to obtain more troops. They were often forcefully persuasive in their

A man being accosted by a regimental officer, aiming to recruit him for military service, *c.* 1830.

approach, and many young men such as the Moor's son would agree and sign up without much idea of what they were letting themselves in for. A career in the army, travel abroad and a regular wage could seem a big attraction especially as at this time Britain had economic problems leading to social unrest.

Recruitment often took place in inns or taverns where potential volunteers could be chatted up having been provided with a pint of strong ale.

An advertisement in the *Norwich Mercury* newspaper states that volunteers for the '54th Regiment of Foot should repair to the King's Head at Brooke, to Sergeant Smith at Seething, to Sergeant Hawke at the sign of the Bear in Fisher's Lane, St. Giles, Norwich, or to Sergeant Arnold in Pocklethorpe, where they will be kindly entertained, and for further Encouragement each man shall receive one Guinea in advance and a Crown to drink his Majesty's health.'

As the letter has only recently been donated there hasn't been time to discover whether the story had a happy ending. Mr and Mrs Moor are not mentioned in the parish records, so didn't stay in the town long. Maybe they moved close to where their son was stationed so they could make a new home for him when he was, we hope, eventually discharged.

W

Winter Ceremonies: Plough Monday

The 'Plough Gathering', as it was known, occurred throughout East Anglia on the first Monday following the Christmas season. In medieval and Tudor times, twelve days of Christmas were celebrated, so the last day of festivities was 6 January and Plough Monday was usually the second week of January. It celebrated the first ploughing of the fields in preparation for spring sowing of seed in March. Winters were much colder in the sixteenth century and during the Tudor period, Britain was in the grip of a 'Little Ice Age', so January could be an exceedingly frosty and snowy month.

Small rural communities such as Bungay relied upon a good harvest of crops, so on the Sunday immediately preceding Plough Monday, a special service was held in the church.

A model of a plough was displayed in the nave, with many bright candles burning around it – the 'Plough Lights' – creating a cheerful scene on a dark wintry day.

Three teams of plough horses on a farm near Bungay, *c.* 1920.

Left: *The Sower,* by Edmund J. Sullivan, from the *Towards the Light* art magazine, 1932.

Below: Hay being loaded on the Le Grys farm near Bungay, *c.* 1925.

The priest then recited prayers of blessing, calling upon God to provide a bountiful harvest, and the words 'God Speed the Plough' were the words on everybody's lips as they tramped home afterwards to their roast Sunday dinners.

On the following Monday evening, the young men of the parish assembled in the churchyard, stamping their feet and blowing on their fingers in the frosty air. This was a big event for them, because it was their role to drag a real plough, supplied by a local farmer, around the town and raise money for church funds. They were escorted by two torch reeves who held their blazing torches aloft to light the way through the dark streets. While some dragged the plough, others played lively tunes on pipes and drums, or danced a merry jig with the pretty maidens who came to cheer them on their way.

At the end of the evening, the money raised was handed over to the churchwardens, and the lads were invited to a feast, perhaps at the Guildhall opposite the church. Both St Mary's and Holy Trinity parishes had their own plough teams and this must often have led to fierce rivalry, sometimes ending in drunken brawls before the night ended.

Lads fighting – drunken fights often ensued in the evenings following the Plough Monday celebrations.

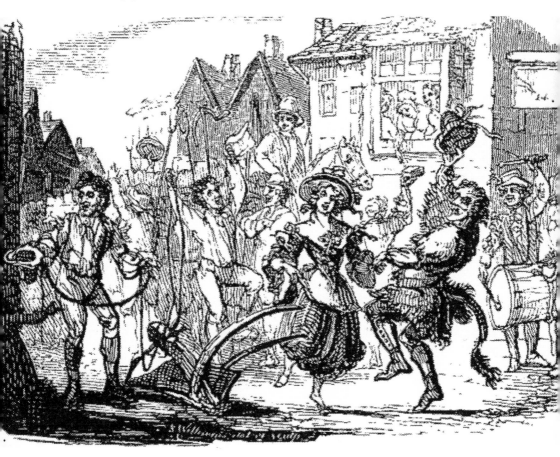

Plough Monday celebrations depicted on a Victorian engraving.

For this reason, and because the church services were increasingly viewed as superstitious, the Plough Gatherings were gradually suppressed in the latter years of the sixteenth century. Bungay managed to retain the event long after it had ceased in other parts of Suffolk, and the final entry relating to it appears in the church registers for 1597.

X Roads

One of the major crossroads in Bungay is on the main road to Flixton, with roads also branching off to Hillside Road and the Saints area. A pub named the Thatched House stood nearby, near the foot of St Margaret's Hill. It dated from the eighteenth century or earlier, and is referred to in the St Mary's Church rates accounts, 1786, as the 'Crossways', enjoying a prosperous trade from travellers journeying in various directions.

In the late Victorian period, cattle were turned out to graze on Stow Fen, close to the Thatched House, traditionally on 12 May. This was a busy day for James Westgate, the pub landlord, as the place was thronged with stock owners and farming folk from dawn to dusk. Occasionally the annual May Horse Fair was also held on Stow Fen,

Flixton crossroads

if its usual location adjacent to St John's Road was flooded. Like many other inns and taverns, the Thatched House suffered a loss of custom during the war years, and finally closed in 1915. It was demolished and replaced by the existing bungalow, 'The Trees'.

In past times, the bodies of hanged criminals were often displayed at crossroads as it meant the maximum number of travellers from all directions would view them, shudder in horror, and resolve to live virtuous lives so they never came to the same grisly end. A children's educational story, entitled *The Rod* (featured in a Georgian publication, *The Penny Histories*), stresses that physical punishment such as caning is essential to teach children the consequences of bad behaviour. It has an illustration of a boy crouching in horror as he gazes at a man hanged on a gibbet, the moral being that this is how he might end up if he doesn't amend his naughty ways.

The Thatched House pub, near the Flixton crossroads, oil painting on copper, *c.* 1800.

Above: Lad peering fearfully at a hanged man on a gibbet, eighteenth-century engraving.

Below: Horse sale on the Mayfair meadow, *c.* 1930.

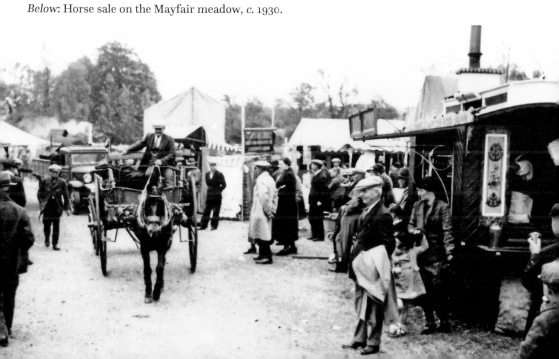

It seems likely that a gibbet might have been stationed near the Flixton crossroads and the bodies of miscreants hanged there occasionally, as happened near other towns.

Turning to a more harmonious topic, my first profound experience of the beauties of nature occurred in that vicinity. I had been for an evening walk with my brothers across the adjacent Stow Fen, and we were returning home along the Flixton Road. The sun was setting, and as we neared the crossroads, I turned to look back and was transfixed by the beauty of the golden orb of the sun sinking low in the sky, amid a mass of billowing clouds tinged with purple and rose. My whole being was shaken by the splendour and atmosphere of the scene. I have enjoyed many sunsets, in many different places since then, but never one which has affected me so deeply as that moment in the Waveney Valley – the beginning of a lifelong affection for the region.

Y

Yuletides of Yesteryear

These days, most working people manage to get a few extra days off for Christmas in addition to the statutory breaks of Christmas Day and Boxing Day. Generally in the past this would only have been those two days plus New Year's Day.

THE YULE LOG

Bringing home the yule log, Victorian engraving.

However, in the medieval period the twelve days of Christmas were celebrated from Christmas Day to 6 January, and for those who could afford it there was feasting and merrymaking throughout. The period was particularly anticipated because the Church decreed a period of fasting beforehand, just as they did for the Easter period but of much shorter duration than Lent – after all, one was to celebrate the Nativity of Christ, whereas the other was his painful suffering and death upon the cross in order to redeem mankind.

In Bungay, as in other towns and villages, the inhabitants decorated their houses with greenery, holly and ivy and sprigs of bright berries. Poorer folk would go from door to door on Christmas Eve, singing carols and hoping to receive a few pence, and we can be sure that the nuns in the Benedictine priory adjacent to the church would hand out baskets of food from the gate in the wall opening near the Market Place. The wealthier townspeople would also hand out 'broken meat' and other leftovers from their meals, and this charitable food was known as 'dole'.

Christmas Day commenced with a church Mass. The earl in Bungay Castle had his own chapel where the Nativity service was held so he didn't need to trudge out into the snow. However, in the town, the churches held three services, the first

Medieval banquet with a measly-looking boar's head – not sufficient to provide a meal for even one of them.

commencing at dawn, when a chorister chanted the whole of the genealogy of Christ from St Matthew's Gospel. He sang from the rood loft, high above the congregation, the pages of his parchment illuminated by many costly candles.

The earl would provide sumptuous feasts throughout the twelve days, and his manorial accounts for 1270 give some idea of the fare. They mention the fattening of pigs, and the salting of venison and fresh fish, taken from the castle's fishponds. His estate at Stow Park provided plenty of deer for meat and also wood for the festive yule logs blazing merrily in the hearth. There was only one hearth in the large and draughty banqueting hall, so even with the blaze you wouldn't feel warm on a winter's night, and you can bet that the Bigod family hogged the warmest places.

A roasted boar's head was a traditional festive dish for the wealthy, boars being grazed on the Bigod's land and other local estates, but boars also roamed wild in the many large areas of forest land. The 'Boar's Head' is one of the earliest Christmas carols and is recorded in a songbooks written in the reign of Henry VIII.

The large and rather grotesque head with all its features intact, in a dish of rich gravy flavoured with herbs, was carried ceremoniously into the awaiting guests around the table, accompanied by pipers, as the words of the carol depict:

The boar's head, in hand bear I,
Bedecked with bays and rosemary,

A wife prepares her husband's dinner – sixteenth-century print.

A boar's head festive dish, Victorian watercolour.

> And I pray you my Masters be merry,
> Quot estis in convivio.

The first record of a Christmas wait in East Anglia is a document in the Public Records Office, dated 1444, referring to a male singer performing in Bungay. He may have performed for a feast at Bungay Castle if it was still inhabited at that time, and visited the homes of other wealthy residents throughout the twelve days of Christmas.

In the previous century, in 1347, Alice, wife of Edward de Montacute, who lived in the castle, became pregnant, and her only child, christened Joan, was eventually born on Candlemas Day in February 1348. It is strange to think of her there in the cold and draughty building trying to keep warm in a bed close to the hearth, and her baby bound up in tight swaddling clothes to ensure it didn't catch a chill. A cause of deaths for various infants in the medieval period was falling into the fire, because their cots, too, had to be positioned near the hearth to provide sufficient warmth.

Midnight Mass heralded the commencement of the Twelve Days holiday. 26 December was St Stephen's Day, and traditionally tenants and employees were provided with a St Stephen's Day feast. It wasn't named Boxing Day until 1849, which was then observed as a holiday and boxes of goods were given to workers, farmhands and household servants.

The fourth day of Christmas was Childermass, which commemorated the children killed by King Herod. Games and sports were enjoyed during the twelve days,

hunting for the rich and archery for the younger men, and for poorer classes games of football, or skating on the frozen rivers and marshes if the weather was icy and snow fell.

The wealthier families also enjoyed a twelfth night banquet for the end of the Christmas season. Gifts were exchanged on 1 January, not Christmas Day as we do today.

In the St Mary's parish accounts, in the sixteenth century, there are frequent references to organ music, as they had several small organs that could be easily moved about as necessary; for example:

> 1523 – Paid to Empson, for a key and mendyn of the orgons – 4*d.*
> 1526 – to Robt. Mann, & John Turnet for settyn uppe the newe orgon – 4*d.*
> to ye Goldsmyth, for mending the two silver sensors for ye orgons and for ye chains – 17*d.*
> 1527 – to Richard Newman for blowing ye orgons – 3*d.*

That there were several organs is made clear by the entry in 1535:

> Paid for mending the organs in the Quire – 12*d.*
> for making of the orgons in the chapel – 8*s.* 6*d.*

Songbooks are also mentioned, and we can imagine that in the Christmas period, sweet-voiced choir boys would be warbling carols and psalms for the Nativity celebrations. Payments are mentioned in the parish accounts for providing robes for the choir boys, and washing and repairing them as required. For example: '1525 – Paid for six new surplyces & cloth for making of three laddes surplices – 17*s.*'

The women who did the washing were quaintly termed 'Lavenders', derived from the Latin word 'lavare' – 'to wash' – and the medieval word 'lavandier', 'a washer-woman'. The accounts for 1523 mention: 'Paid to the Lavendyr for wasshying of four Aubis – 4d. [priest's albs, clerical robes].'

Zoos, Zebras and Zany Creatures

Since medieval times, people were fascinated by strange creatures living in foreign lands, of which fabulous tales were told by travellers, and artists' impressions appeared in handwritten and illustrated books.

Some of these depictions were not very accurate and gave an odd impression of what the animals looked like. Kings and queens and wealthy aristocrats started to collect animals transported from abroad as curiosities to show off to their friends and guests. Then, increasingly from the eighteenth century, travelling menageries

A Victorian menagerie.

became popular. In 1767 on Beccles Common the local press advertised: 'A Menagerie – a Capital Collection of living curiosities ... two lions, a tyger, a Tartarion Satyr, or Wild Man of the Woods ... the Lions are greatly esteemed for their Docility and majestic appearance, and the oriental Tyger strikes at first view with Pleasure and Surprise at his noble size and the many beautiful stripes that adorn his body.'

The 'Tartarion Satyr' was some sort of freak human, as menageries often included humans or animals that were unusually deformed, and drew great interest and laughter from visitors – a very cruel practice, but the whole set-up was extremely cruel from our modern viewpoint, as wild animals were kept confined in small cages and travelled in wagons over rough roads for hours at a time.

In the following year there was a larger menagerie in the Market Place at Norwich: 'Lion, Leopard, Capuchin, Horned Owl, Baboons, Racoon, Mongoose, Opossum etc. The Proprietor being willing that working Hands and Servants may see this curious Collection, they will be shown to the above at as low a price as 2d.'

Sometimes individual animals were put on display. In February 1783, the *Norwich Mercury* newspaper reported:

Just arrived and to be seen in a most commodious room adjoining Mr. Matthew's Glass warehouse at the upper end of Norwich Market Place, a most beautiful female Dromedary ... her being pregnant is a Circumstance very favourable to the curious in general, as well as to Naturalists in particular ... also a most beautiful Porcupine. Gentlemen – 1s. Tradesmen – 6d. Servants and children – 3d. 9am – 8pm.

Bungay people would attend these events and occasionally similar smaller shows would visit the town during the two annual fairs.

In the Victorian period, the national touring show Wombwell's Mammoth Menagerie visited Bungay. George Wombwell had commenced collecting and exhibiting rare and foreign animals in the early nineteenth century. An advertisement in the *Norwich Mercury* in 1821 describes his touring exhibition to all parts of the region, when it was promised that:

Amateurs and connoisseurs will have an opportunity of viewing at one glance almost every rare and valuable Quadruped, Bird, and Reptile that ever were imported into this Kingdom ... for there are no less than nine Lions, besides beautiful Silver Lions, Tigers, Leopards, Panthers, Striped and Spotted Hyenas, Ocelot or Tiger in Miniature, the Civit and Musk Cat, real Jackalls, Ant Eaters, Cotimundis, Cavies and Ogoties.

The list also included zebras, camels, elephants, kangaroos, sea cows, porcupines, monkeys and apes, rattlesnakes, boa constrictors, serpents, crocodiles, a great variety of smaller animals and birds and 'an immense large ANIMAL brought from the frozen

Wombwell's menagerie wagons arriving in Outney Road, Bungay, *c.* 1887.

regions near the North Pole: he is perfectly white and his limbs are as large as those of an elephant'.

The last mentioned animal was presumably a polar bear of the type that ate an Eton schoolboy a couple of years ago while he was on a camping holiday with school mates in the polar regions. But what were the 'Cotimundis' and 'Ogoties'? Answers please, on a postcard to the publishers, and you could win a free copy of this book.

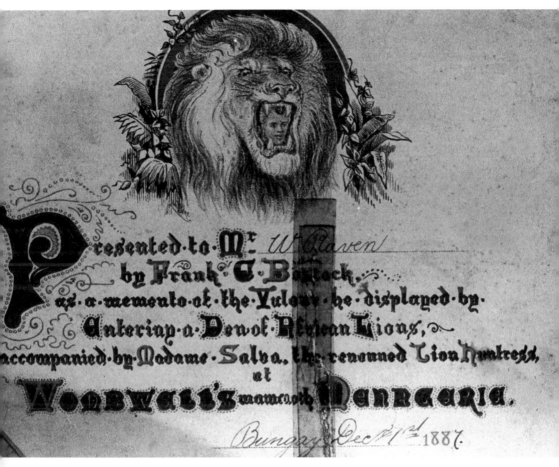

Certificate awarded to William Raven for daring to enter the lion's den at Wombwell's menagerie, December 1887.

The menagerie site was Bungay Common in 1887, and it proved a very popular attraction, although the number and variety of animals was much reduced compared with the 1821 advert, consisting of around thirty animals including twelve lions, eight tigers, three elephants and three giraffes.

One of the main attractions was the lions' den, especially when the proprietor whipped up excitement and tension by challenging members of the audience to dare enter it. William Raven, aged twenty-nine and presumably of small size because he was nicknamed 'Tit', went boldly in, and was given a certificate to record his bravery. However, he tragically died less than two months later, thought to be as a result of his terrifying experience.

The White Swan pub in the Market Place had a large rear yard where various events were held. During May Fair week it held its own fair, which occasionally included a small 'Wild Beast show'. Archie Brown could remember visiting it in the 1890s when he was still a schoolboy.

Above: The White Swan – small displays of animals were shown in the late Victorian period in the rear yard.

Below: A Victorian zoo in London.

When the Royal Society for the Prevention of Cruelty to Animals was founded in the earlier Victorian period, they commenced trying to improve conditions for both domestic pets, farm animals and those that were displayed in zoos or travelling shows. The illustration of the animals in the Victorian London Zoo shows how pitifully they were confined, with scarcely room to stretch or turn round, and on display just for ignorant people to gawp and giggle at. There has been continued improvement, but much cruelty to animals still persists, and it's only comparatively recently that performing animals in circuses have been viewed as inhumane and they are now less frequent.

Kindness and compassion to all living creatures should be a chief aim for mankind.

Bibliography

Goodwyn, E. A. – *Elegance and Poverty – Bungay in the Eighteenth Century.* (Morrow & Co. 1989)

Goodwyn, E.A. – A Beccles & Bungay Georgian Miscellany. 1980.

Goodwyn, E. A. – *Selections from Norwich Newspapers, 1760 – 1790.* (Printed by the East Anglian Magazine. c. 1978)

Mann, Ethel – *Old Bungay* (Heath Cranton, 1934)

Mann, Ethel – *An Englishman at Home and Abroad: the Diaries of John Barber Scott.* Vol. 1 – 1792 – 1828 (Morrow & Co.1988)

Mann, Ethel – *An Englishman at Home and Abroad.* Vol. 2 – 1829 – 1862 (Morrow & Co. 1996).

Reeve, C., Honeywood, F. & Morrow, P. *The Town Recorder: A History of Bungay in Photographs.* (Morrow & Co. 1994) (as above): *The Town Recorder, Vol. 2, Five centuries of Bungay at Play,* (Morrow &. Co. 2008).

Reeves, M. E. *The Mediaeval Village: Then and There Series,* (Longmans, 1954), from which the line drawing illustrations of the huntsmen, and hogs being fed acorns, by F.E. Gorniot have been derived.

Ridgard, John – *Bungay – Translations and Transcriptions from six original manuscripts, illustrating aspects of Bungay's Local History between 1269 and 1786.* (published by the Bungay Branch of the Workers Educational Association, 1975)

Walton, Ruth – *Writers of the Waveney Valley,* 2019.

The archives of Bungay Museum.